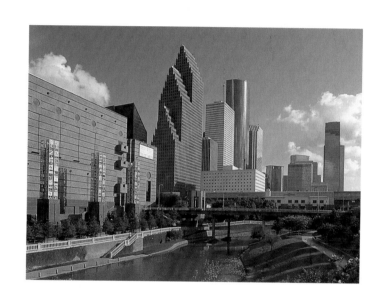

HOUSTON

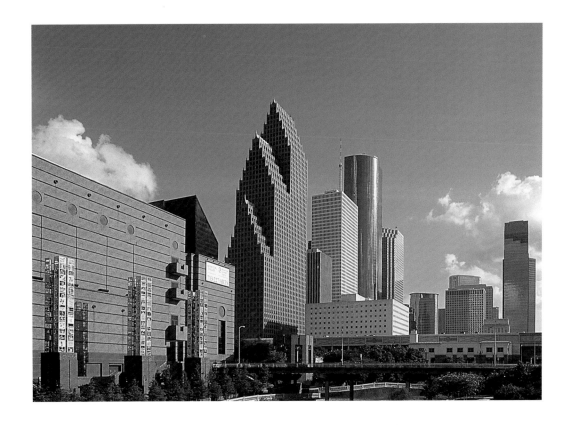

WHITECAP BOOKS

Text by Tanya Lloyd Kyi
Edited by Elaine Jones
Photo editing by Tanya Lloyd Kyi
Proofread by Lisa Collins
Cover and interior layout by Jacqui Thomas

Printed and bound in Canada

National Library of Canada Cataloguing in Publication Data

Kyi, Tanya Lloyd, 1973–
 Houston

 (America series)
 ISBN 1-55285-415-9

 1. Houston (Tex.)—Pictorial works. I. Title. II. Series: Kyi, Tanya Lloyd, 1973—
America series.
F394.H843 K94 976.4'1411064'0222 C2002-911393-8

The publisher acknowledges the support of the Canada Council and the Cultural
Services Branch of the Government of British Columbia in making this publication
possible. We acknowledge the financial support of the Government of Canada through
the Book Publishing Industry Development Program for our publishing activities.

For more information on the America Series and other Whitecap Books
titles, please visit our web site at www.whitecap.ca.

Lush bayous, waterside walks, art galleries, theaters, and museums— to the uninitiated, this may not sound like Houston. The largest city in Texas was built primarily on oil, and rigs are still a common sight in the region. Downtown, skyscrapers stand testament to the success of the industry. Yet the metropolis has grown beyond its oil-field roots, to become a place of diverse commerce and culture.

Houston residents are already well acquainted with the city's advantages, but to the millions of sightseers and conference attendees who arrive each year, the area holds many surprises. Nestled in the shadow of office towers, the Theater District is home to the Grand Opera, the Houston Ballet, and large and small theater companies. Nearby, the Museum of Fine Arts, the Children's Museum, and the Museum of Health and Medical Science are just some of the institutions exploring subjects from the history of Texas to the marvels of the human body.

For those seeking more active pursuits, the region's 500 parks encompass 42,000 acres of land and 12,200 acres of water, including portions of the 10 waterways that first attracted settlers to the area. These green areas offer visitors cycling, swimming, golfing, paddling, and more. Just outside the city, the Kemah Boardwalk, George Ranch Historical Park, and nearby Galveston Island provide further diversions.

Houston is also a hub of technology. Its name was heard from the moon on July 20, 1969, as astronauts reported: "Houston, Tranquility Base here. The Eagle has landed." The Johnson Space Center continues to lead American exploration of the galaxy. Much has changed since military commander Sam Houston helped win Texas from Mexican forces. Augustus C. Allen and John K. Allen, the brothers who founded the city, would now find it unrecognizable. But the Houston of today, America's fourth-largest city and a place rich in financial and artistic achievements, bears witness to the wisdom of their choice.

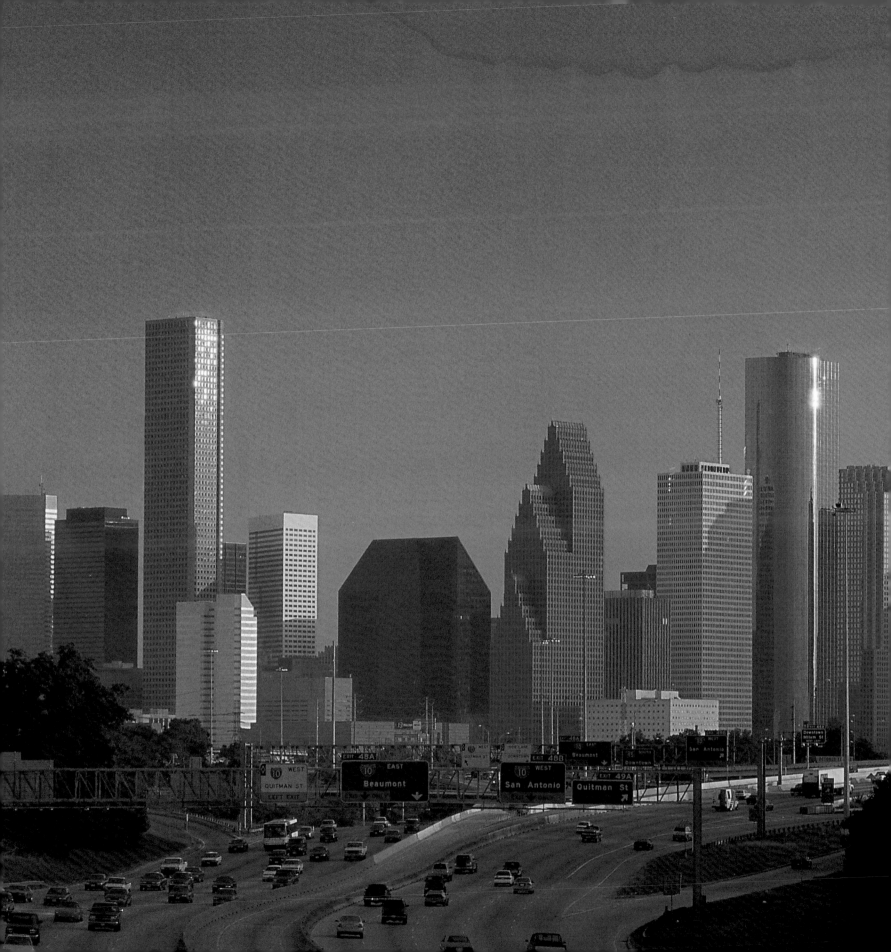

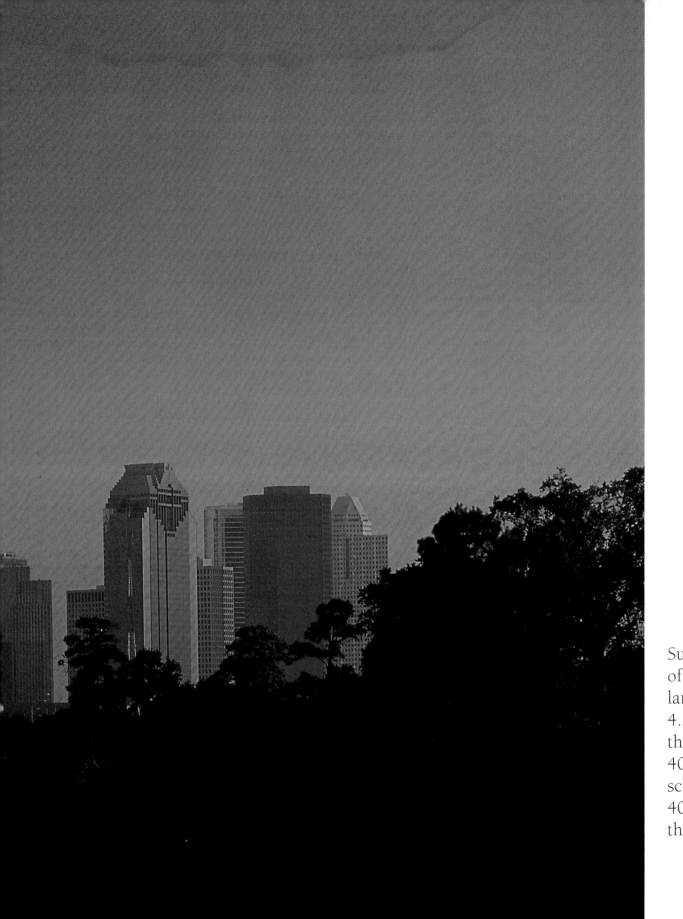

Sunset lights the skyline of the nation's fourth-largest city. Home to 4.3 million people, the metropolis boasts 40 post-secondary schools, 26 museums, 400 parks, and more than 4,000 restaurants.

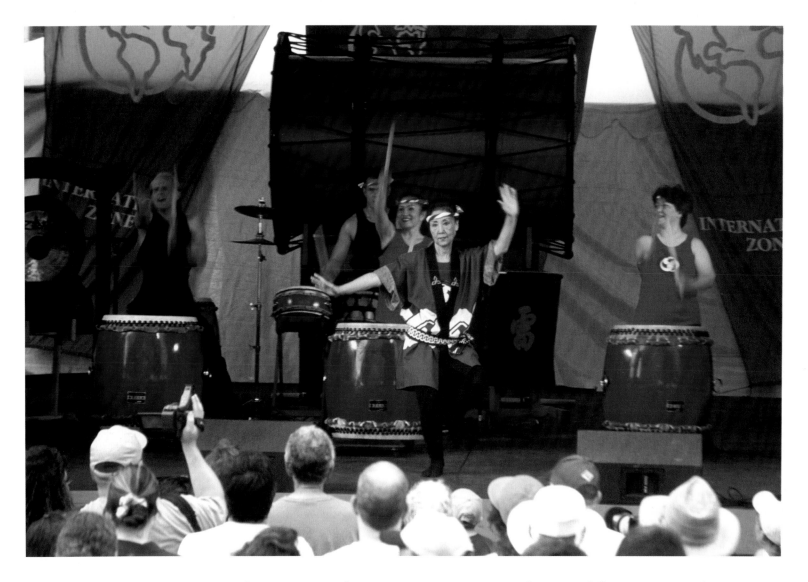

Twelve stages at the Houston International Festival feature more than 1,500 performers, from traditional Asian dancers to African pop artists. Each summer, the festival focuses on a different country, bringing a comprehensive look at another culture to the streets of Texas.

The Houston International Festival began as a small arts celebration in the 1970s and has grown to include craft markets, an arts fair, and performers from around the world. Events now encompass 20 city blocks, in venues from local parks and squares to streets and sidewalks.

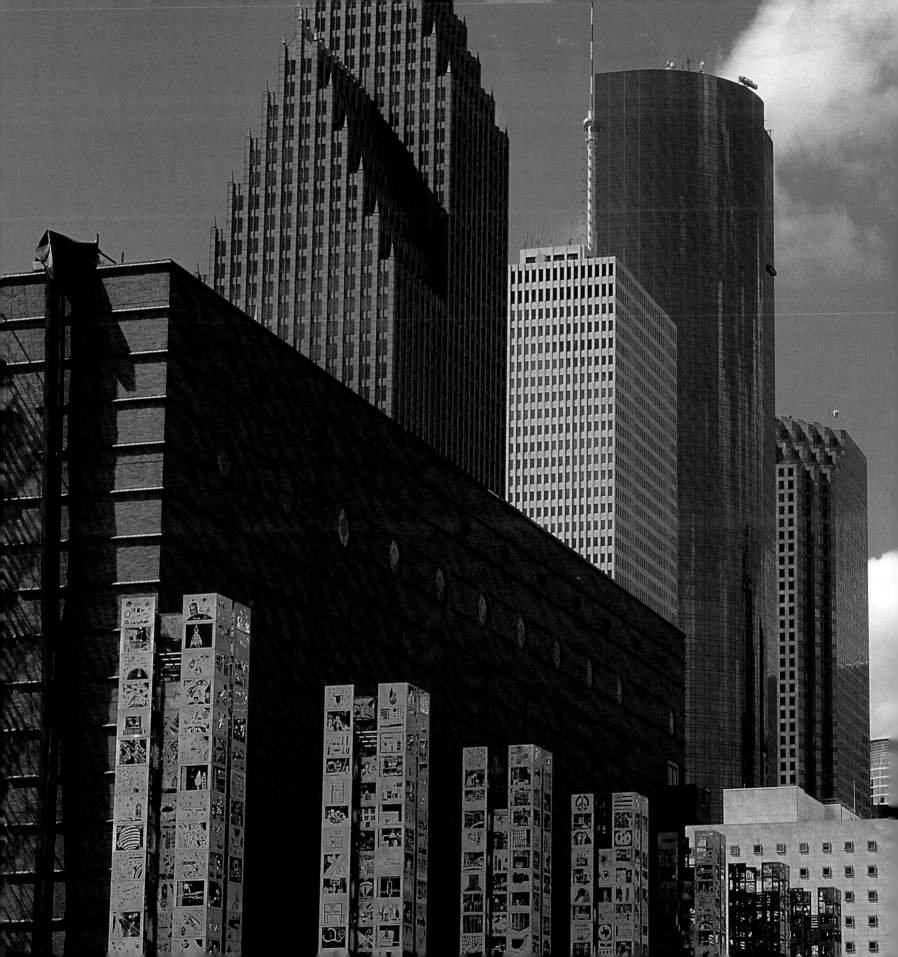

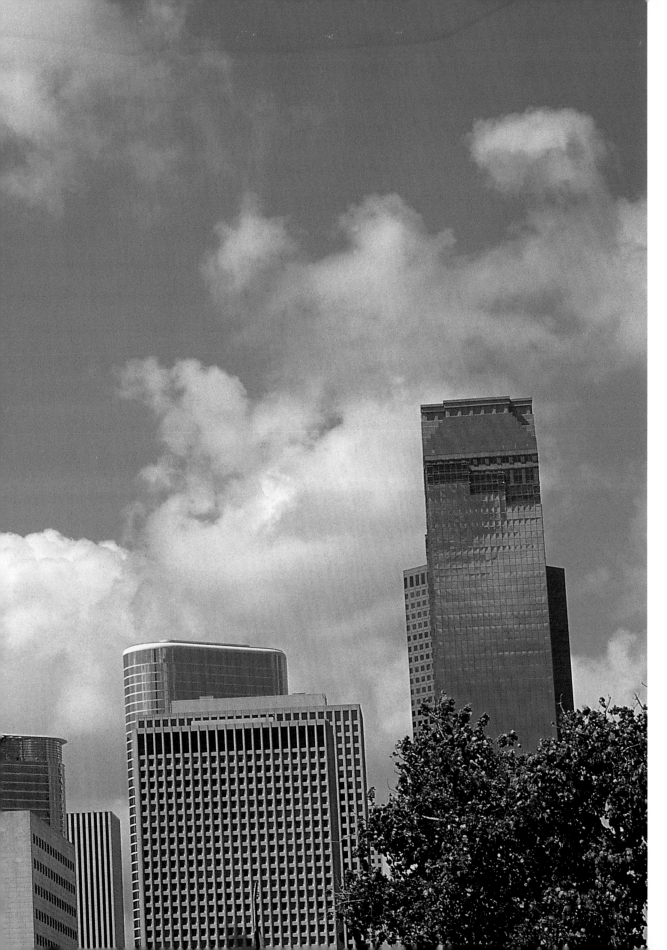

Houston's vibrant down-town district is home to 12 Fortune 500 companies and more than 2,000 corporate head offices. With a workforce of 153,000 and more than 22 million visitors each year, the downtown core is also the city's fastest-growing residential area.

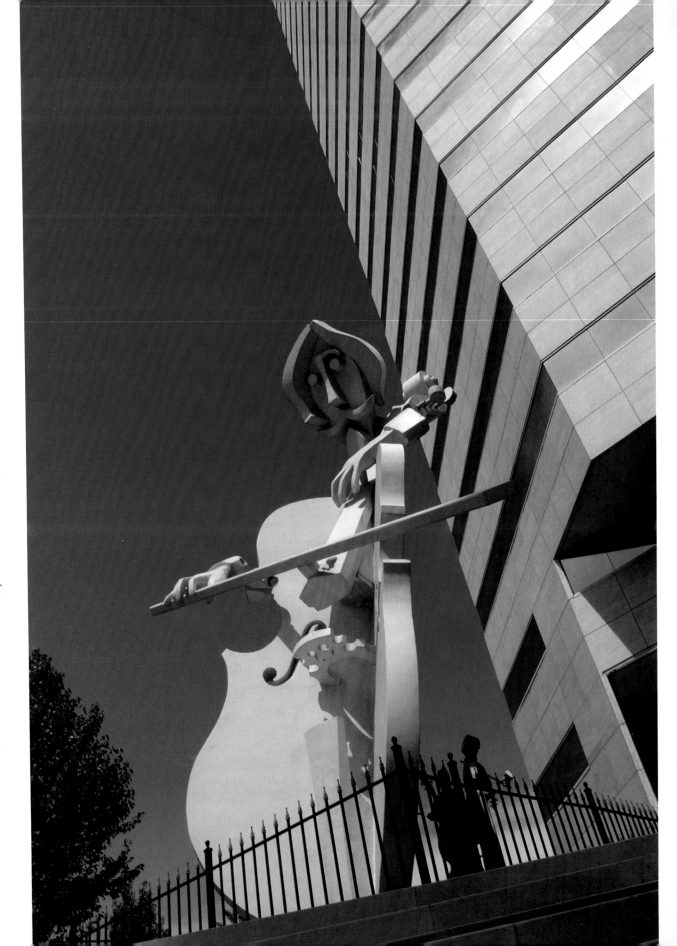

Lyric Center is a 26-floor office building in the core of the Theater District. The stylized cellist by local artist David Addickes is a good choice for this location—the Houston Ballet and the Houston Grand Opera are just across the street at Wortham Center.

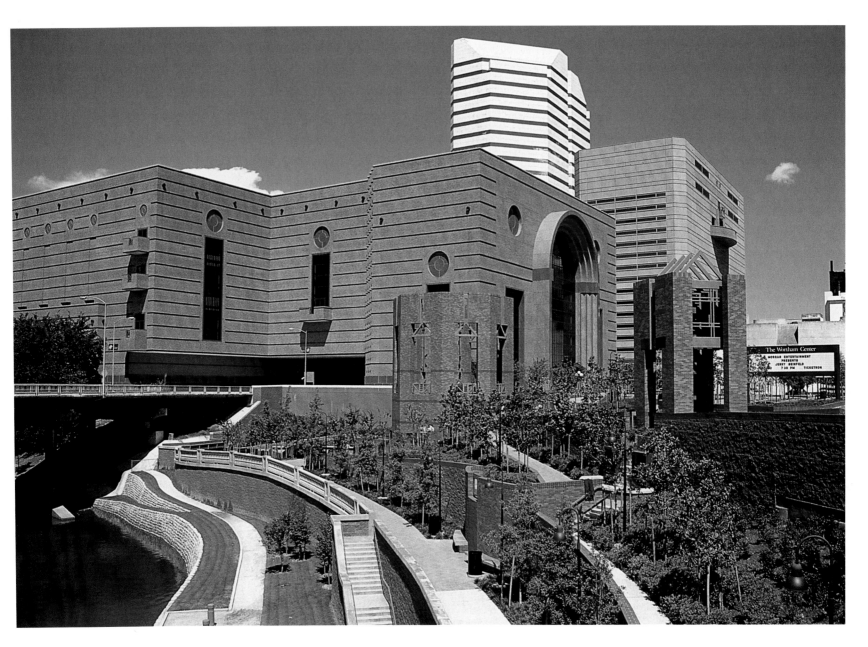

Home to the Houston Grand Opera and the Houston Ballet, Wortham Center lies at the heart of the downtown Theater District. The 17-block neighborhood includes eight performing arts venues with a combined 12,000 seats—an entertainment district second only to New York City's.

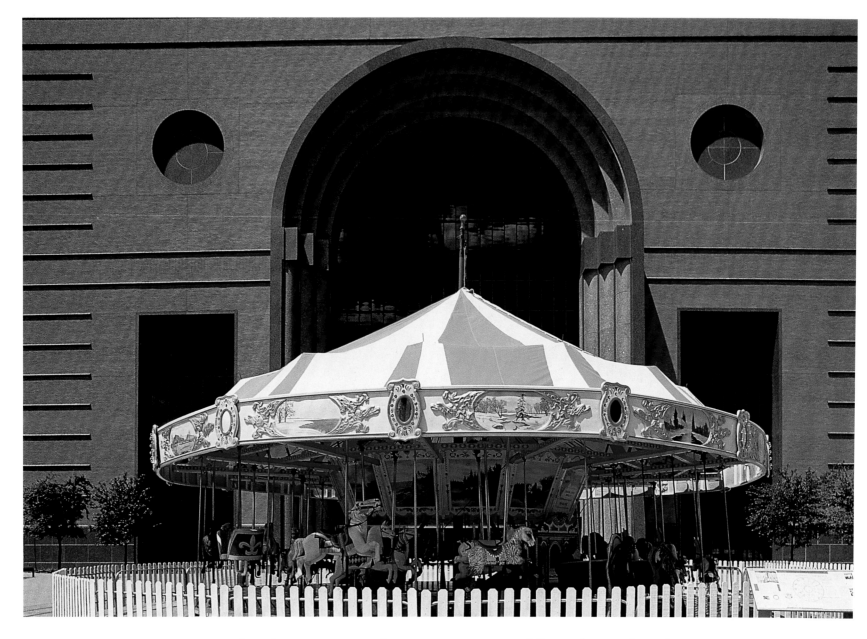

Completed in 1987, Wortham Center is named for its largest benefactor, insurance company founder Gus S. Wortham. Over 2,000 other citizens also contributed. The elaborate arches and luxurious interior were created by architect Eugene Aubry.

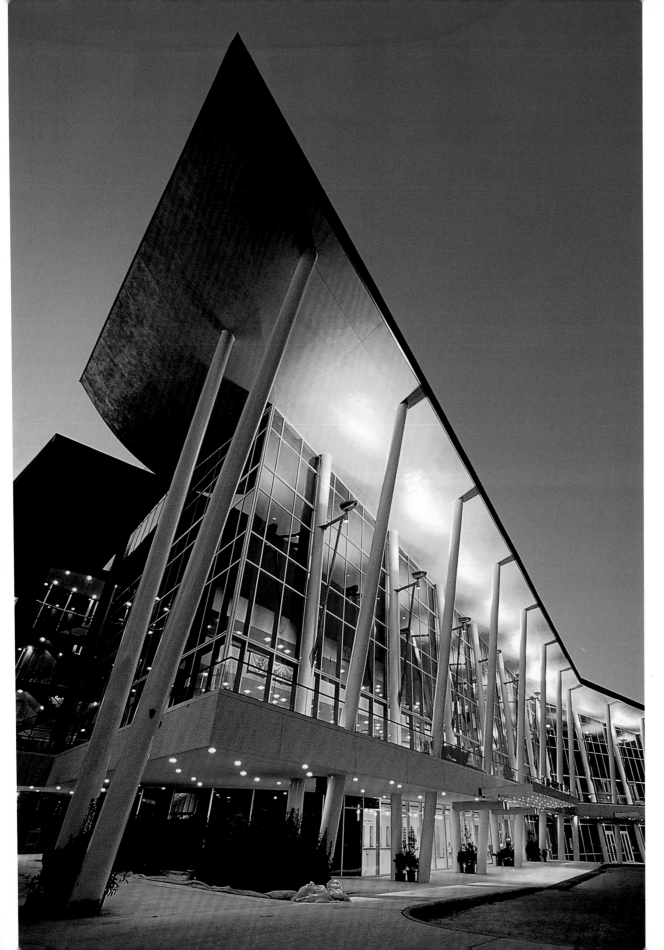

Completed in 2002, the Hobby Center hosts touring performers in two sumptuous theaters. The largest, Sarofim Hall, seats 2,650. The center is named for former lieutenant governor, Houston businessman, and philanthropist Bill Hobby, who donated $12 million for its construction.

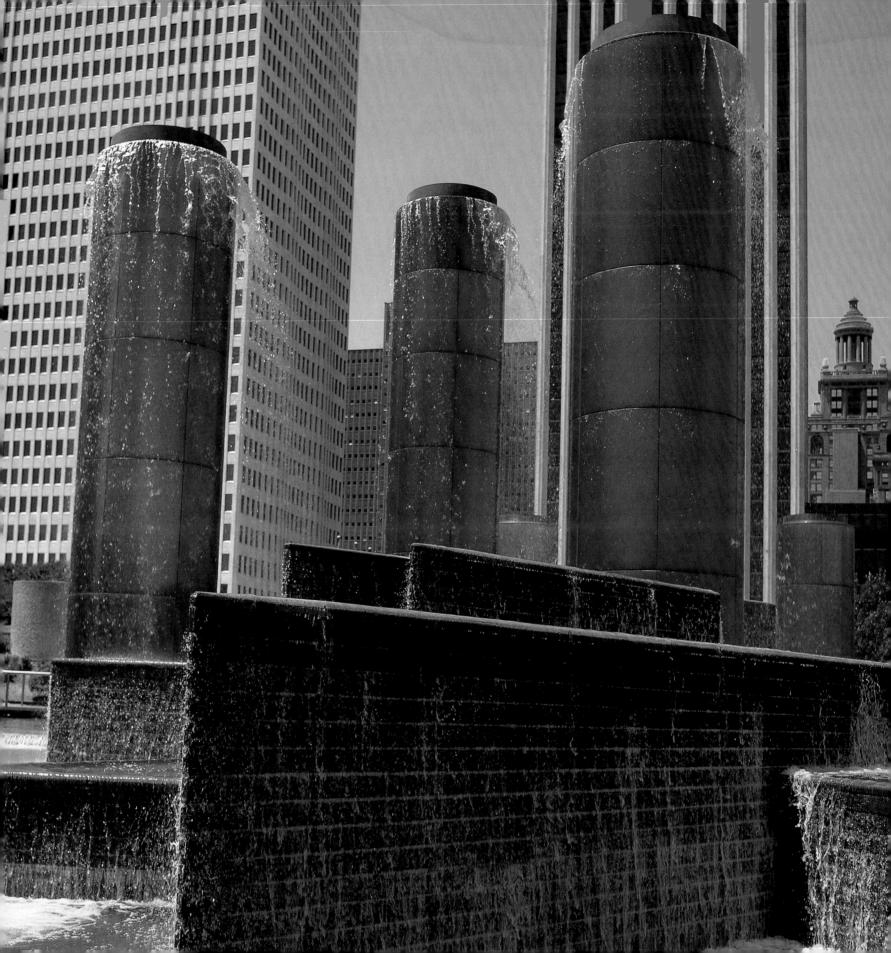

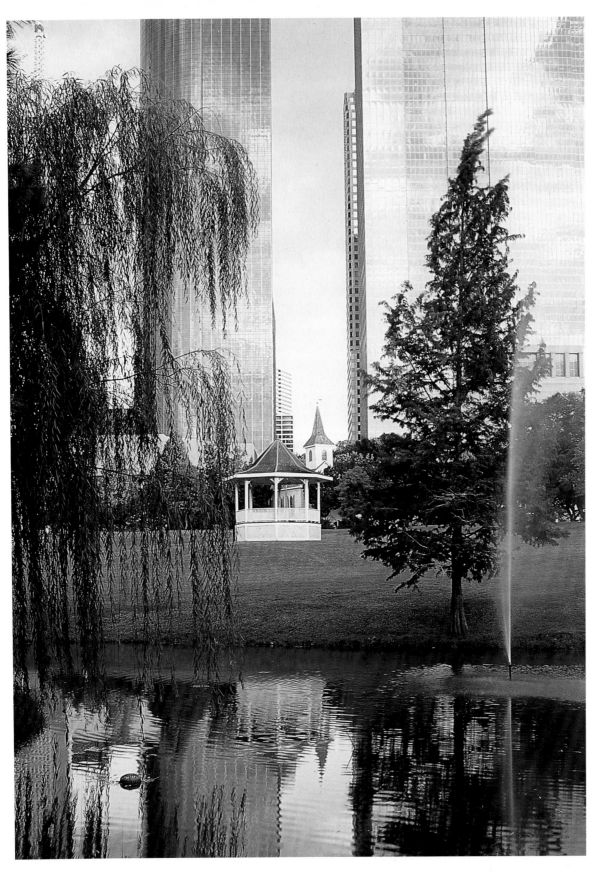

When mayor Sam Brashier bought this land in 1899, it lay on the outskirts of Houston. Once the home of local businessman Nathaniel Kellum, then the site of the area's first private school, today, Sam Houston Park's 19 acres are a natural oasis in the shadow of the city's skyscrapers, a refuge just steps from downtown.

FACING PAGE
Tranquility Park is named for the moon's Sea of Tranquility, where astronauts first landed. Near this futuristic fountain with its rocket-shaped towers, sightseers discover a set of footprints made by the boots Neil Armstrong wore during his lunar landing.

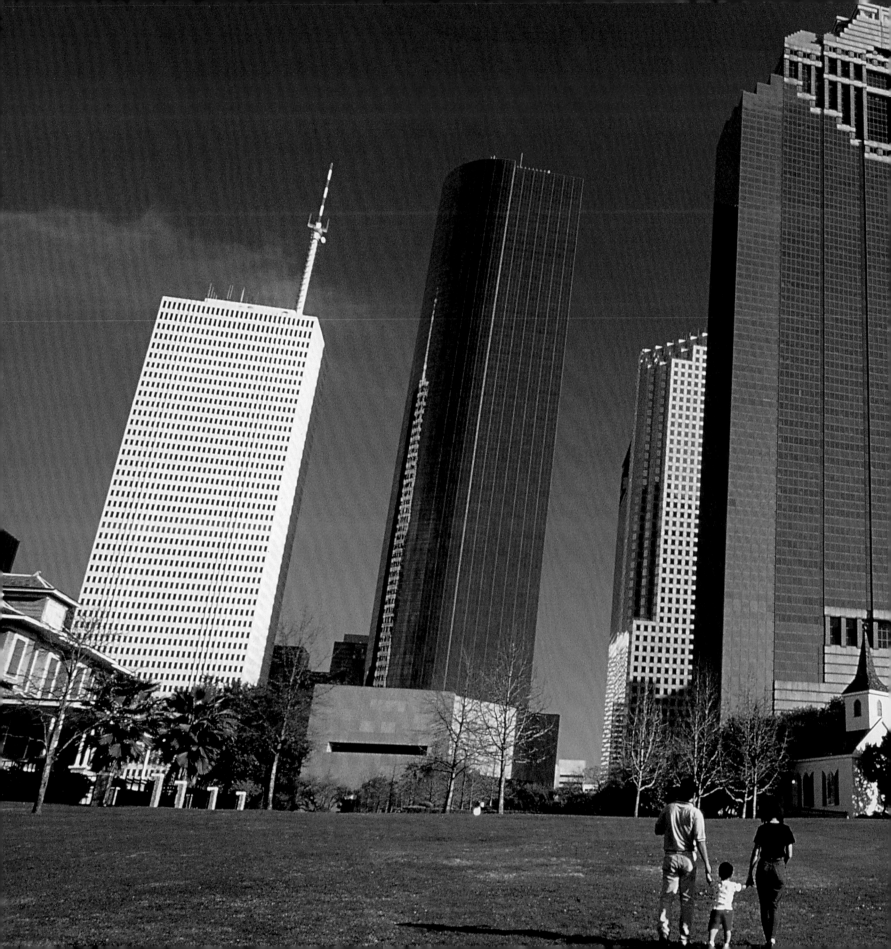

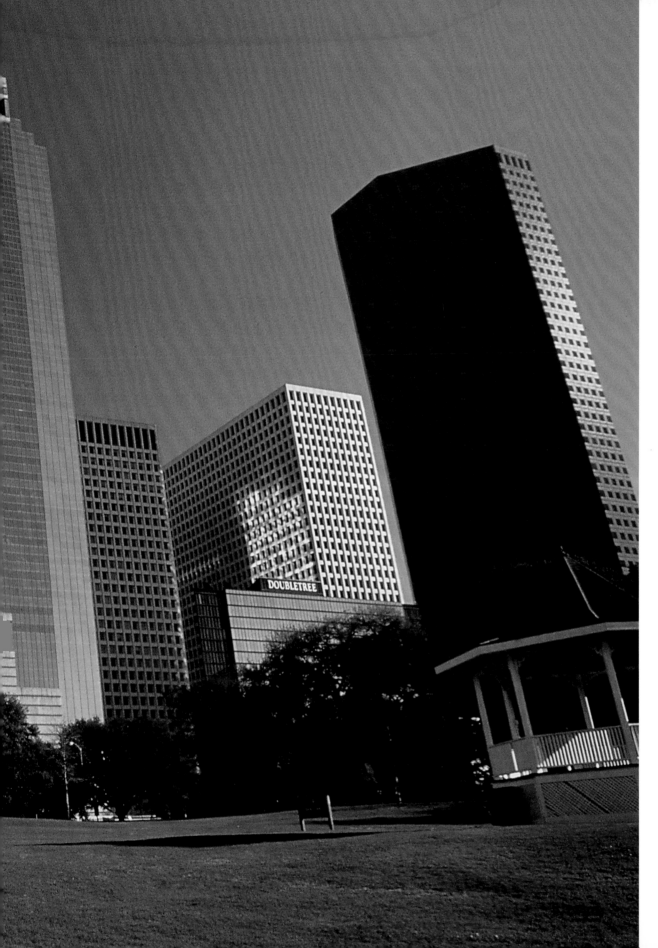

Much of downtown Houston was built on the profits of black gold, after oil was discovered just outside the city in 1901. In the last few decades, however, the city's economy has diversified and Houston is now a center for technology, health care, and tourism.

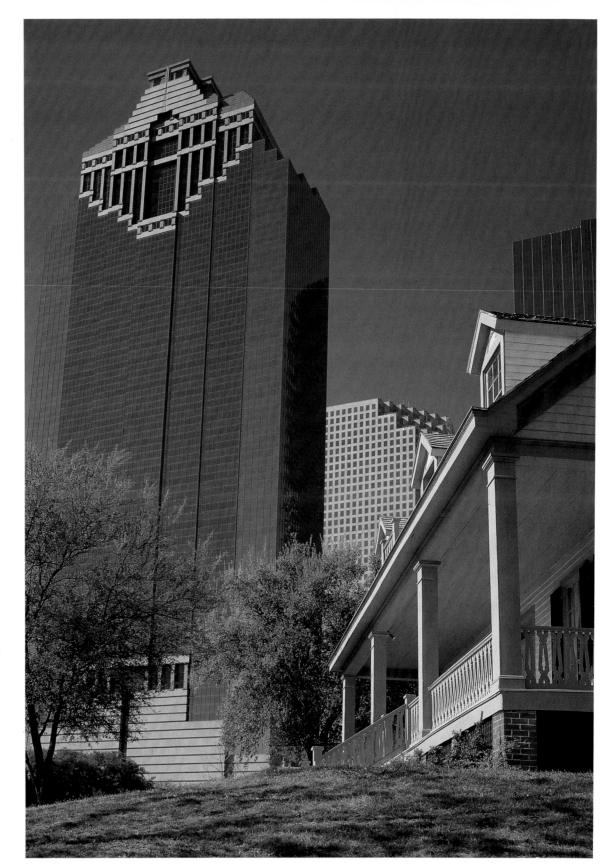

Home to the Heritage
Society since 1954,
Sam Houston Park
features rolling lawns,
a bandstand, and eight
historic buildings, dating
from 1823 to 1905.
Restored to reflect
the diverse periods
of Houston's past, the
structures attract hun-
dreds of school children
and visitors each year.

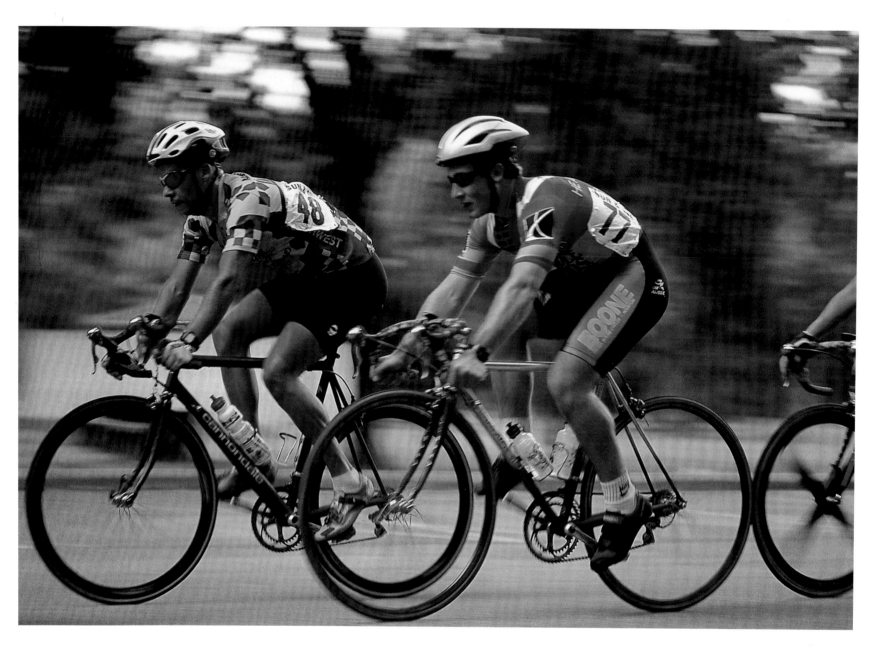

Houston has facilities for both recreational and competitive cycling. Weekend enthusiasts can follow 13 miles of trails through Brays Bayou or pedal the paths of Memorial Park. For serious athletes, the city offers road races and the state's only velodrome.

Founded in 1865 by two ministers and a small congregation of newly freed slaves, Antioch Missionary Baptist Church was Houston's first predominantly black church. The present sanctuary was built 10 years later, then repeatedly expanded to accommodate a growing congregation. The church was named a Texas Historic Landmark in 1994.

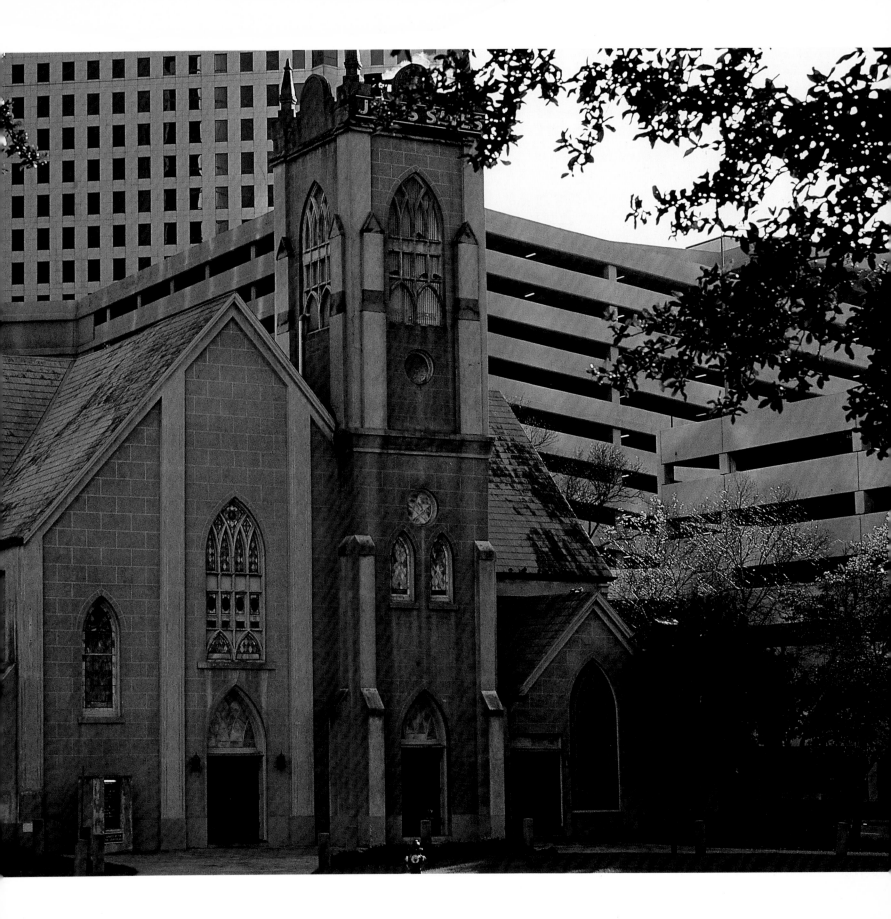

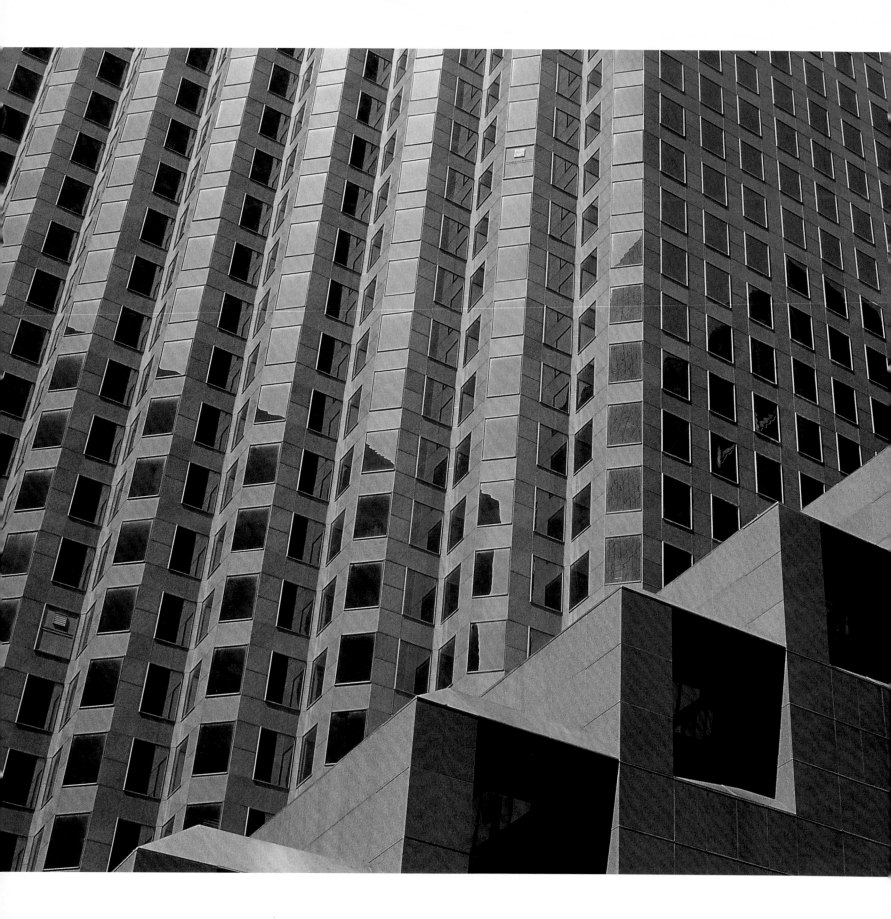

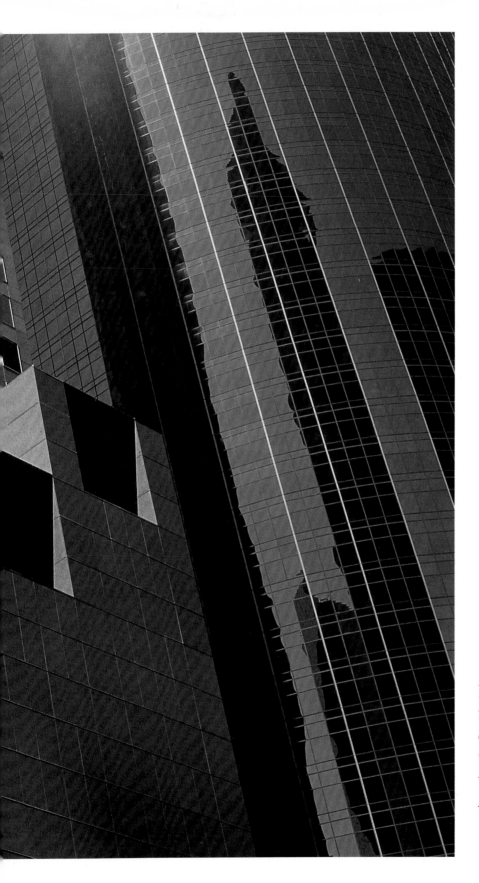

From 1837 until 1839, Houston enjoyed a brief reign as the capital of Texas. The city's first developers, Augustus C. and John K. Allen, convinced the government to temporarily relocate to Houston when the Mexican Army's advance threatened Austin, the home of the legislature.

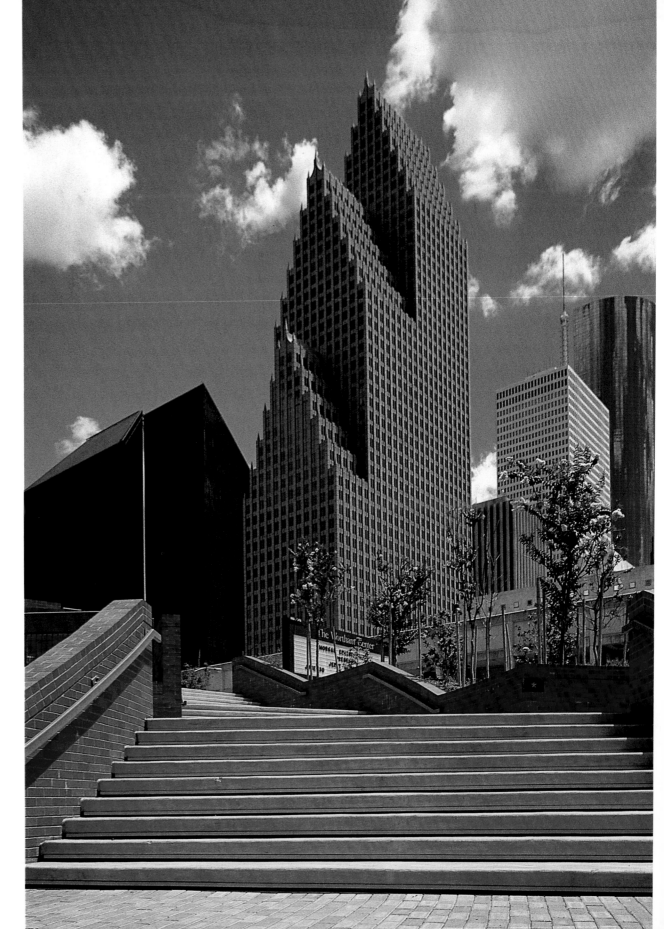

Created by Ohio-born architect Philip Johnson, the gables of Houston's Bank of America Center were inspired by the tiered buildings of the Netherlands. Red Swedish granite gives the building its pink hue. The 56-story sky-scraper was completed in 1983.

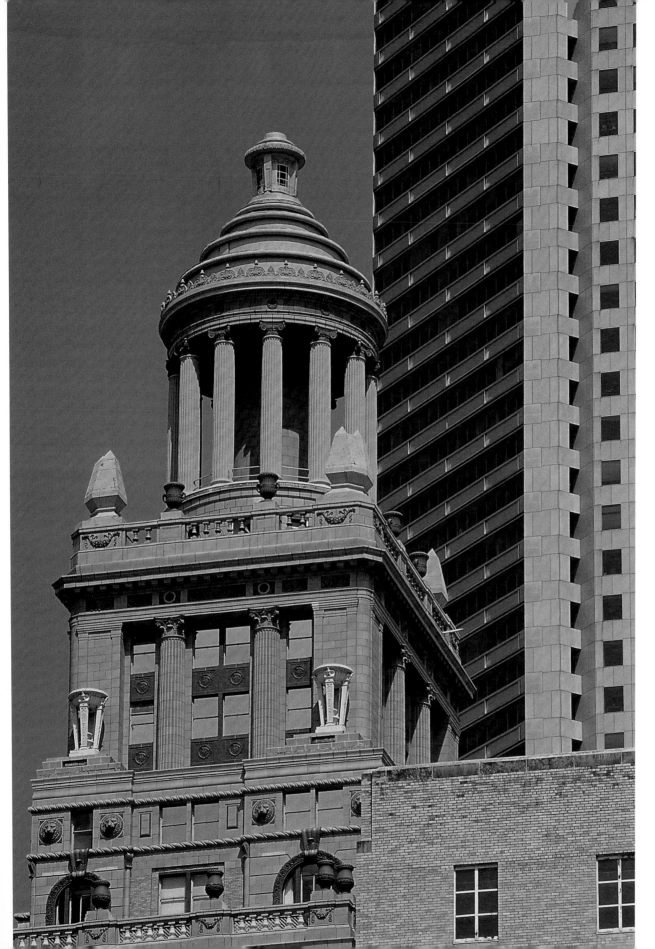

Dwarfed by its glass and steel neighbors, it's hard to believe the Niels Esperson building was the tallest building in Texas when it was completed in 1927. The 32-story structure was commissioned by Melli Keenan-Esperson and named for her late husband, a real estate and oil developer. Some Houston residents claim that Melli's ghost roams the tower.

27

Home to City Hall, Hermann Square was designated a historic site by the city in 2001. Local cattle rancher, real estate developer, and oil baron George H. Hermann bequeathed the land to Houston in 1914. Landscape architecture firm Hare & Hare later designed the distinctive reflecting pool and formal plantings.

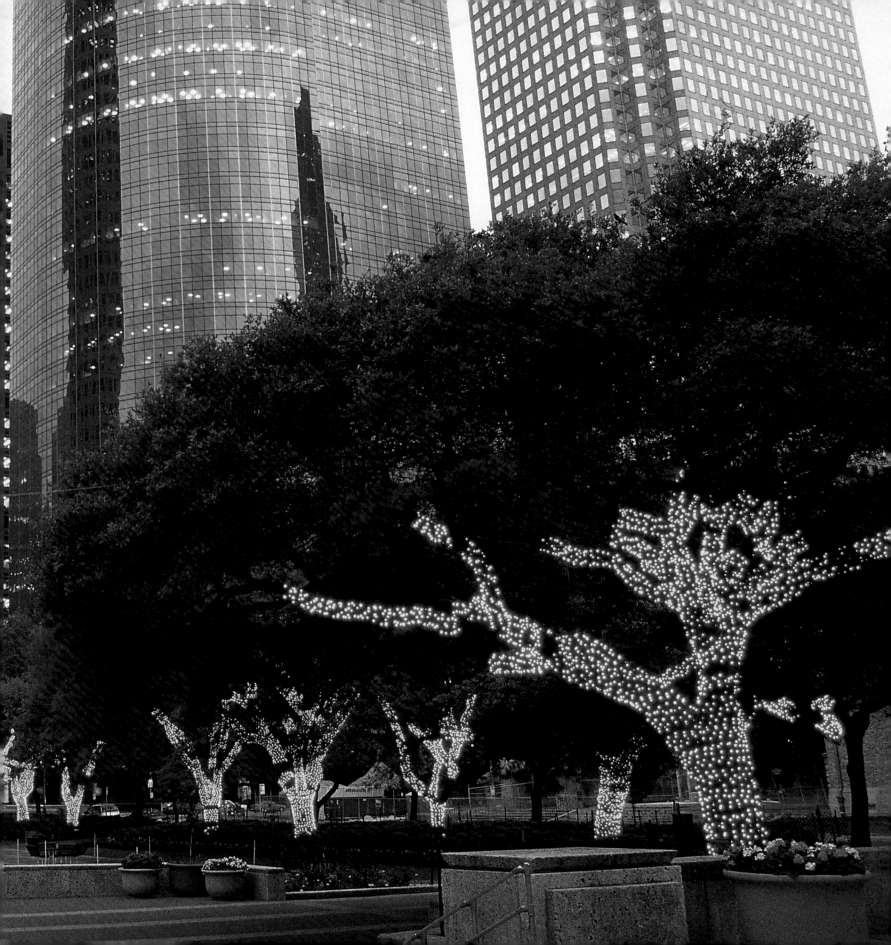

The two 36-story towers of Pennzoil Place are separated by only 10 feet. Designed
by Johnson/Burgee Architects of New York and S. I. Morris Associates of Houston,
the structure presents a different façade from every perspective and allows plentiful
natural light into the offices. The complex revolutionized high-rise design.

The highest building in Houston, JPMorgan Chase Tower features a popular
observation deck on its sixtieth floor. The skyscraper was designed by world-
renowned architect I. M. Pei. The colorful sculpture at the entrance to the building
is Joan Miro's *Personage and Birds*.

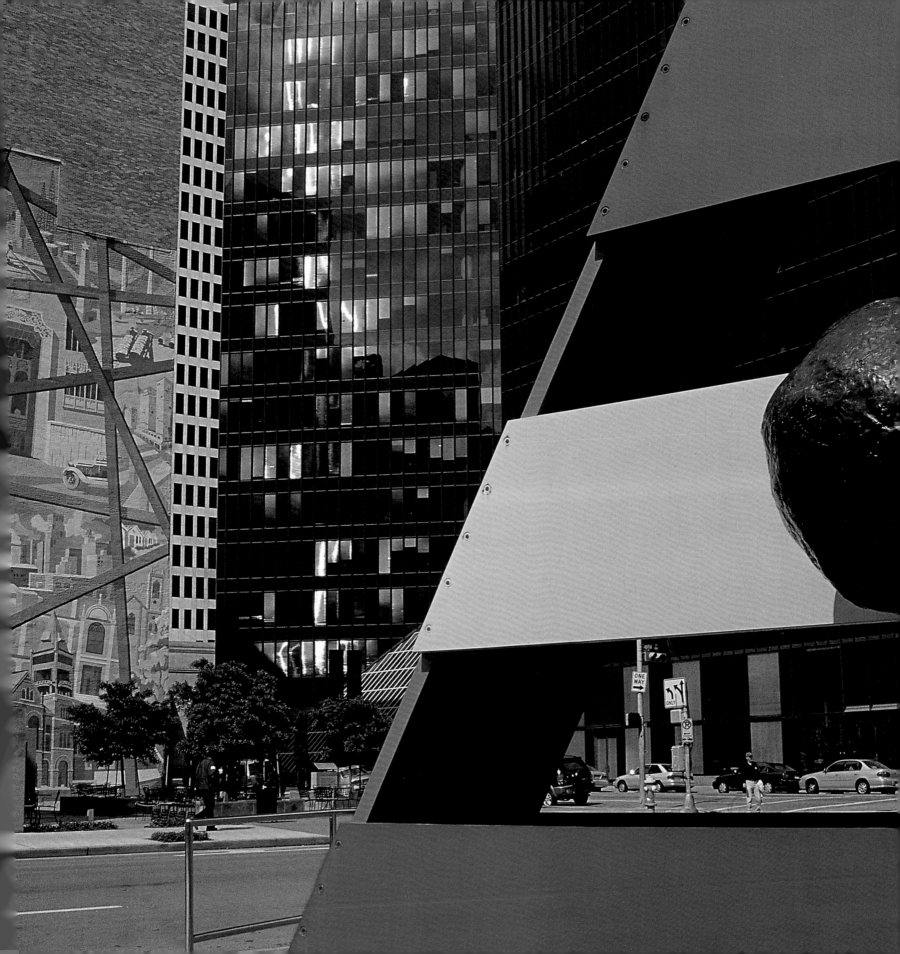

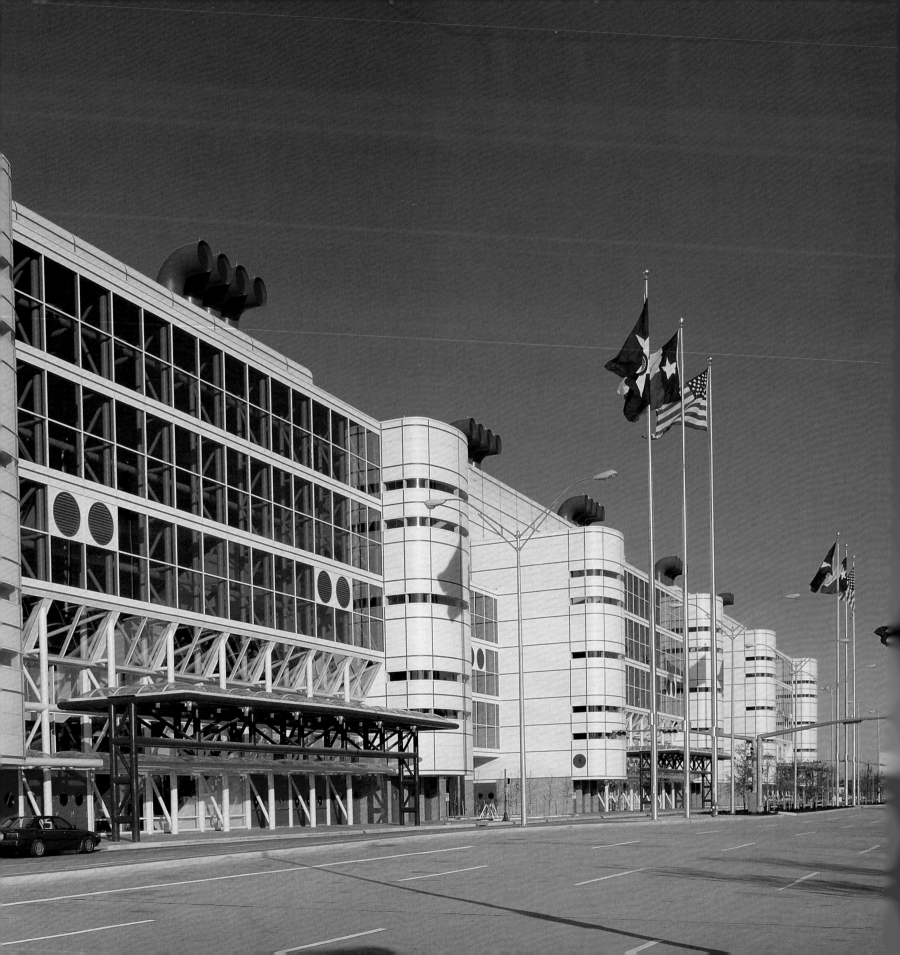

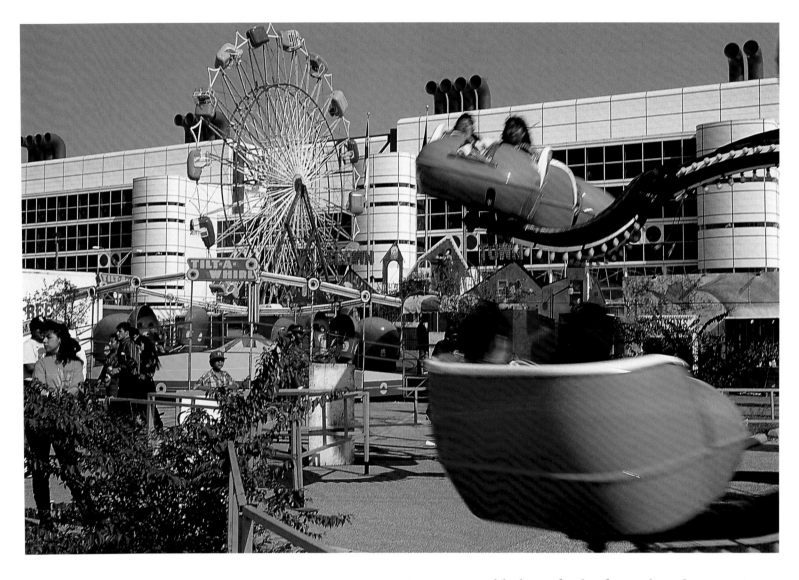

In any season, visitors to Houston are likely to find a festival underway. From the Children's Festival each March and summer's International Jazz Festival to the Fiestas Patrias Hispanic celebrations in August and the Christmas Candlelight Tours, the city's calendar is packed with diverse multicultural events.

One of the largest convention facilities in the American South, the George R. Brown Convention Center includes an arena, a ballroom, and more than a million square feet of exhibition space. Convention guests are in the heart of the city, only minutes from Houston's theaters and attractions.

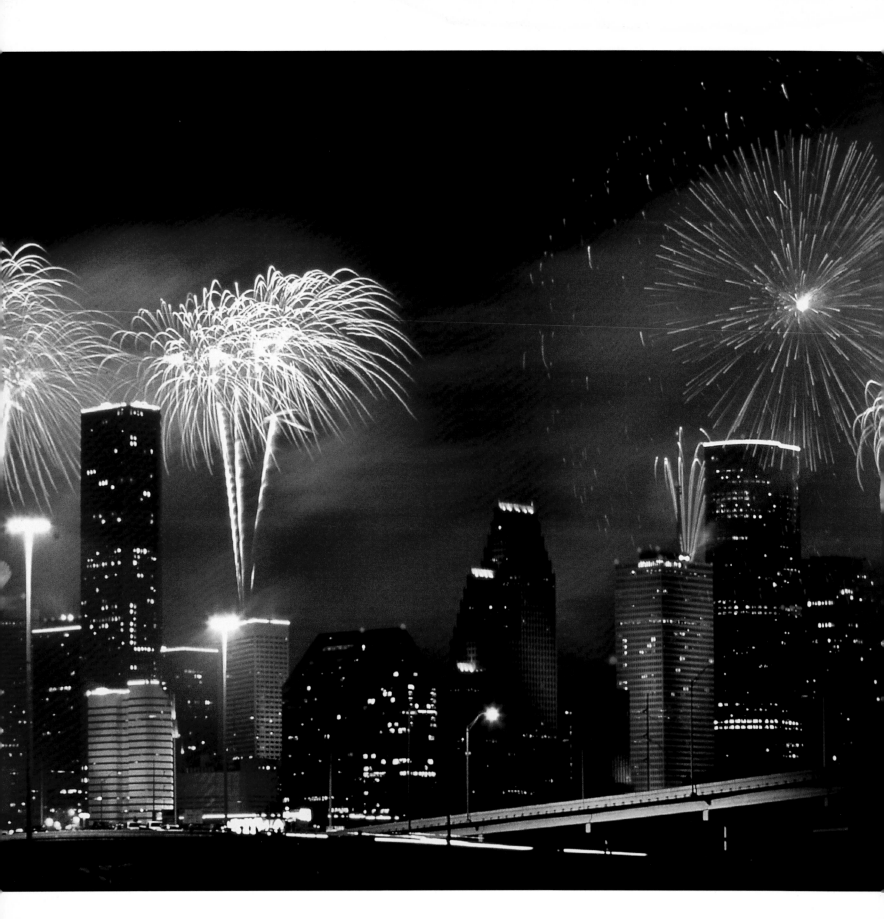

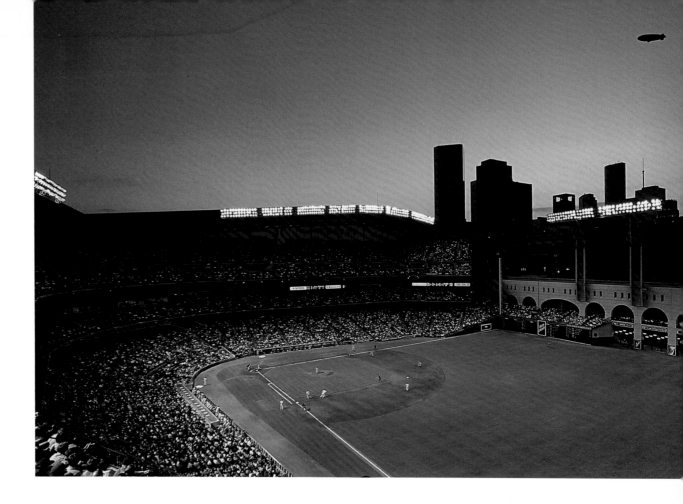

Home of the Houston Astros baseball team, Minute Maid Park opened in 2000 and claimed a National Honor Award for Engineering Excellence. The ballpark features a 242-foot-high retractable roof.

Although many travelers see only the 90-block city core, the city of Houston occupies about 600 square miles and the greater metropolitan area encompasses more than 8,700 square miles —a region eight times the size of Rhode Island.

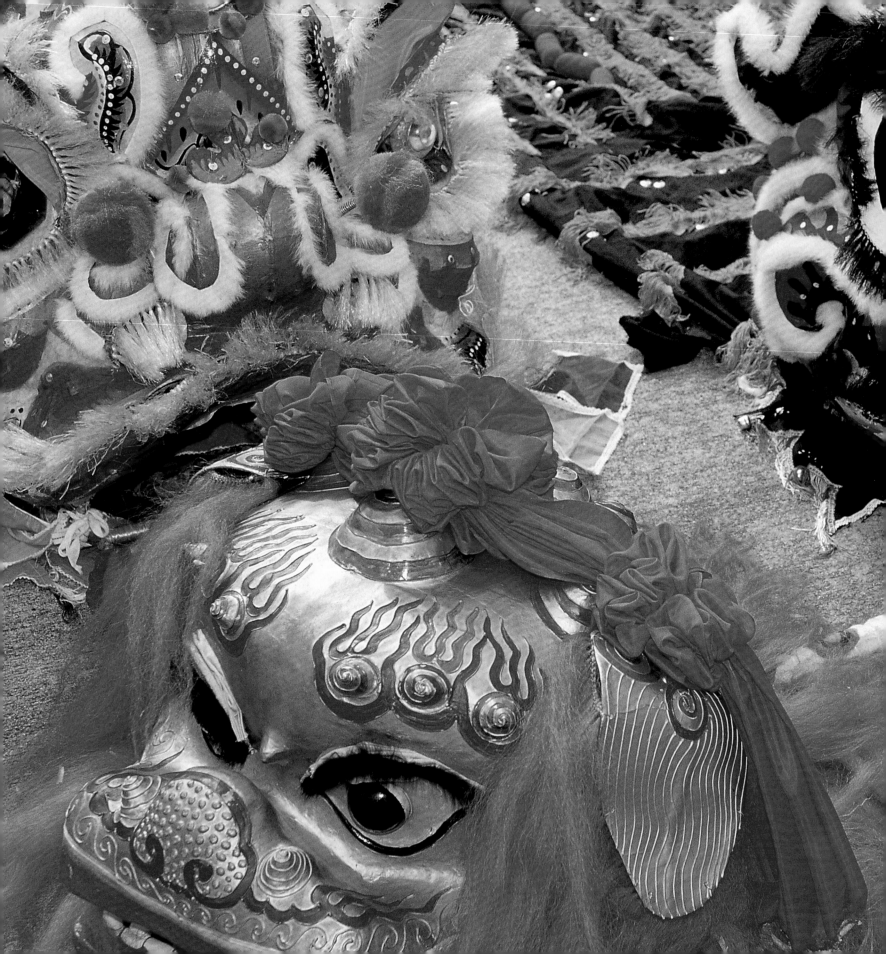

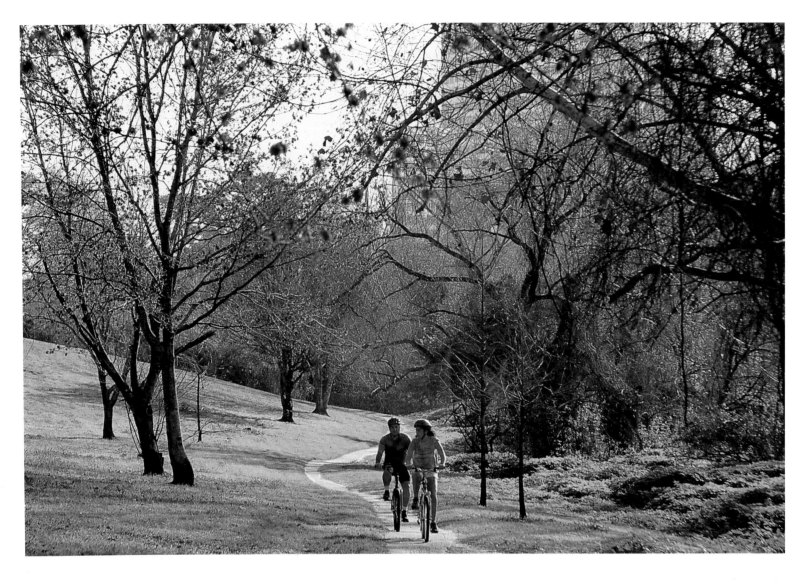

Bicycle rentals allow Houston sightseers to escape the busy streets and wind their way along the cycle paths of Memorial or Hermann parks. Hermann Park alone attracts 5.5 million vistors each year.

Old Chinatown is a faded, 50-block area once home to many of Houston's Asian residents. Yet between the warehouses and boarded-up shops, wanderers may still discover unique wares and restaurants. The city hopes the nearby George R. Brown Convention Center and Minute Maid Park will revitalize the neighborhood.

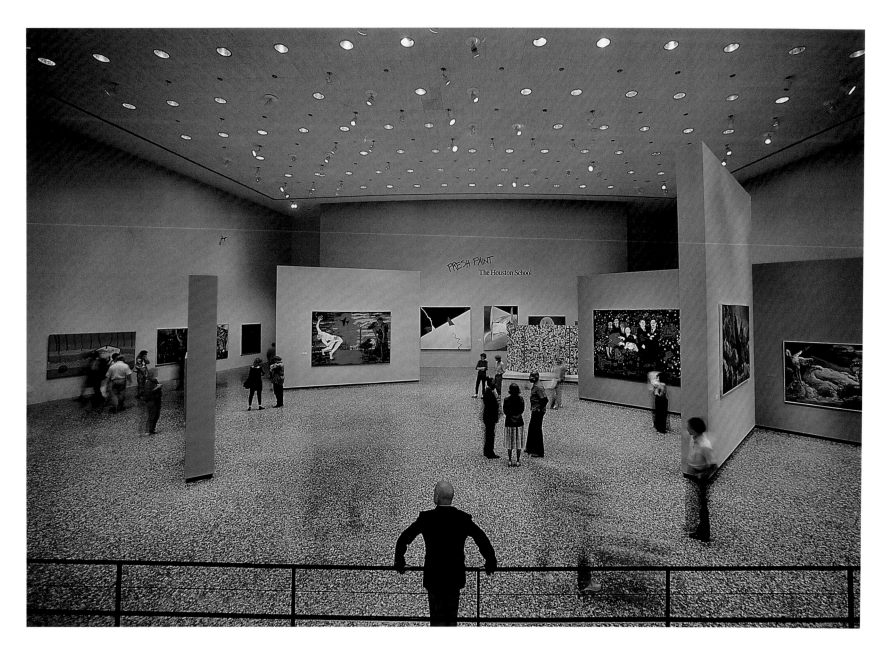

With a collection of more than 45,000 works of art, Houston's Museum of Fine Arts draws 2.5 million visitors each year. Its exhibits include French Impressionist paintings, Pre-Columbian gold artifacts, and modern American works. The museum also features an expansive outdoor sculpture garden.

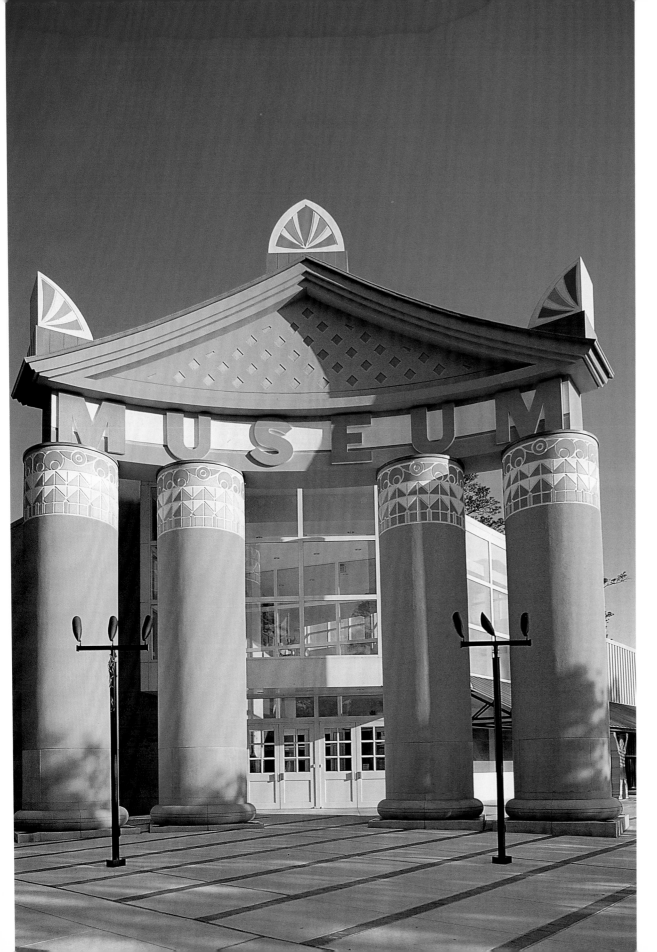

Interactive exhibits at the Children's Museum of Houston allow kids to explore subjects such as science and technology, history and culture, and health and the human body. Young visitors can host a puppet performance, create a nature journal, or tackle a collection of tricky brain teasers.

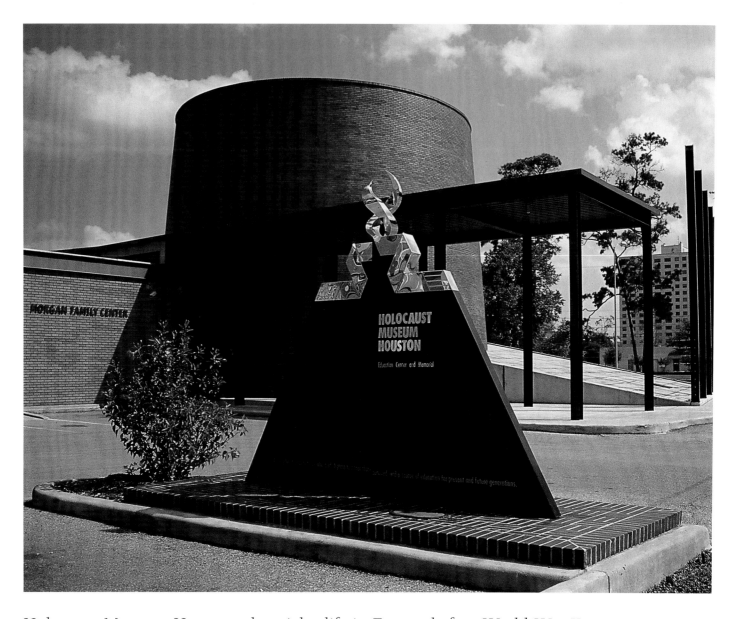

Holocaust Museum Houston chronicles life in Europe before World War II, through the Nazi regime and its aftermath. Exhibits include a memorial to those who died, a collection of art from the period, and a film depicting the experiences of Houston residents who survived the Holocaust.

Along with permanent and traveling exhibits, Holocaust Museum Houston contains 4,000 books about Judaism and the Holocaust, videos, posters, and about 200 oral histories of survivors and witnesses. These materials help the museum promote tolerance and respect for people of all religions and ethnicities.

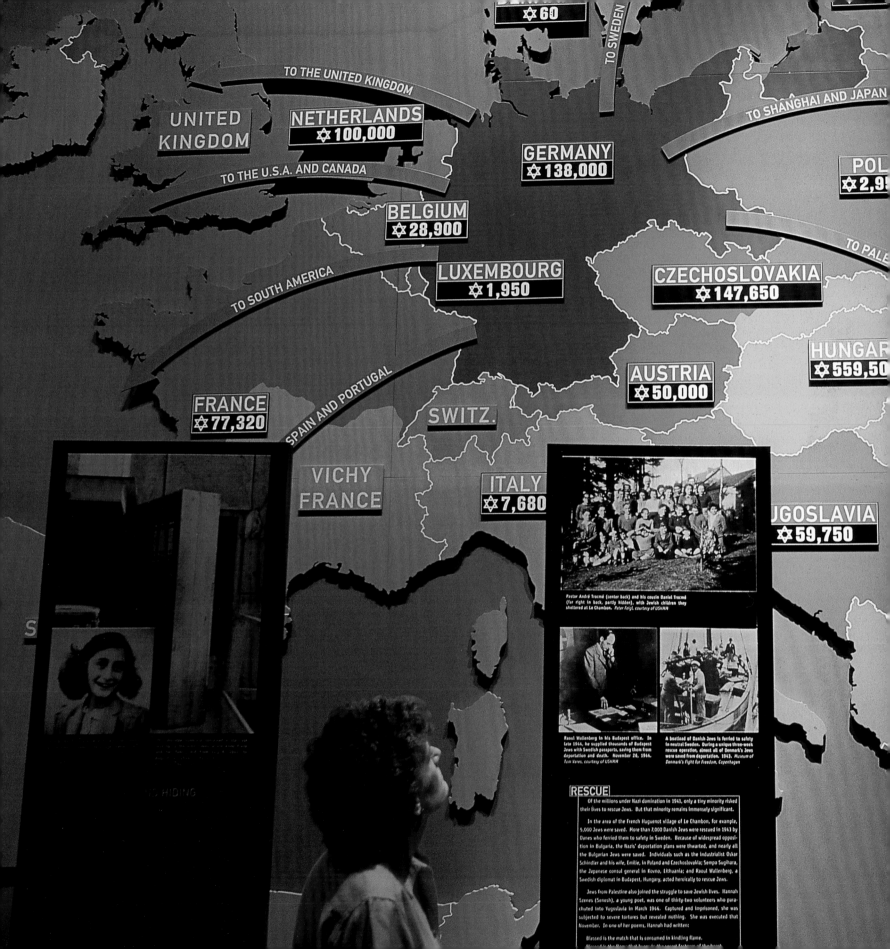

☆ 60

TO THE UNITED KINGDOM

UNITED KINGDOM

NETHERLANDS
✡ 100,000

TO SWEDEN

TO SHANGHAI AND JAPAN

GERMANY
✡ 138,000

POL
✡ 2,9

TO THE U.S.A. AND CANADA

BELGIUM
✡ 28,900

TO SOUTH AMERICA

LUXEMBOURG
✡ 1,950

CZECHOSLOVAKIA
✡ 147,650

TO PALE

HUNGAR
✡ 559,50

FRANCE
✡ 77,320

SPAIN AND PORTUGAL

SWITZ.

AUSTRIA
✡ 50,000

VICHY FRANCE

ITALY
✡ 7,680

UGOSLAVIA
✡ 59,750

Pastor André Trocmé (center back) and his cousin Daniel Trocmé (far right in back, partly hidden), with Jewish children they sheltered at Le Chambon. *Peter Feigl, courtesy of USHMM*

Raoul Wallenberg in his Budapest office. In late 1944, he supplied thousands of Budapest Jews with Swedish passports, saving them from deportation and death. November 26, 1944. *Tom Veres, courtesy of USHMM*

A boatload of Danish Jews is ferried to safety in neutral Sweden. During a unique three-week rescue operation, almost all of Denmark's Jews were saved from deportation. 1943. *Museum of Denmark's Fight for Freedom, Copenhagen*

NO HIDING

RESCUE

Of the millions under Nazi domination in 1941, only a tiny minority risked their lives to rescue Jews. But that minority remains immensely significant.

In the area of the French Huguenot village of Le Chambon, for example, 5,000 Jews were saved. More than 7,000 Danish Jews were rescued in 1943 by Danes who ferried them to safety in Sweden. Because of widespread opposition in Bulgaria, the Nazis' deportation plans were thwarted, and nearly all the Bulgarian Jews were saved. Individuals such as the industrialist Oskar Schindler and his wife, Emilie, in Poland and Czechoslovakia; Sempo Sugihara, the Japanese consul general in Kovno, Lithuania; and Raoul Wallenberg, a Swedish diplomat in Budapest, Hungary, acted heroically to rescue Jews.

Jews from Palestine also joined the struggle to save Jewish lives. Hannah Szenes (Senesh), a young poet, was one of thirty-two volunteers who parachuted into Yugoslavia in March 1944. Captured and imprisoned, she was subjected to severe tortures but revealed nothing. She was executed that November. In one of her poems, Hannah had written:

Blessed is the match that is consumed in kindling flame.

Featuring an interactive journey through an enormous human body, the John P. McGovern Museum of Health and Medical Science provides a unique perspective on medicine and health. From a tour of the human head in the Skull Dome to the inner workings of the ear, the museum dazzles more than 50,000 school children each year.

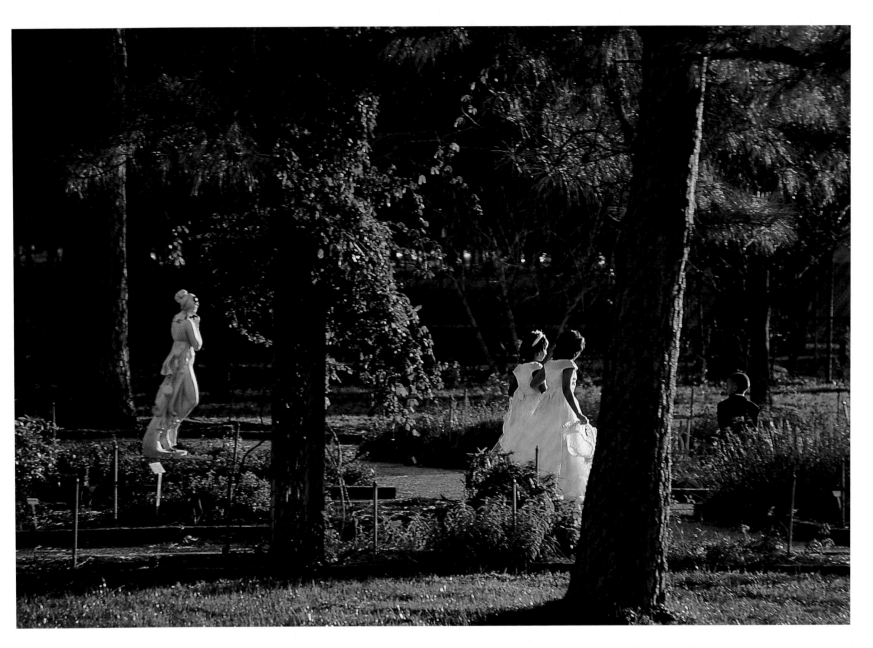

The formal gardens of Hermann Park make it a popular place for wedding photographs. The 407-acre preserve includes picnic, cycling, horseback riding, baseball, and tennis facilities, as well as a zoo, a garden center, and the Museum of Natural Science.

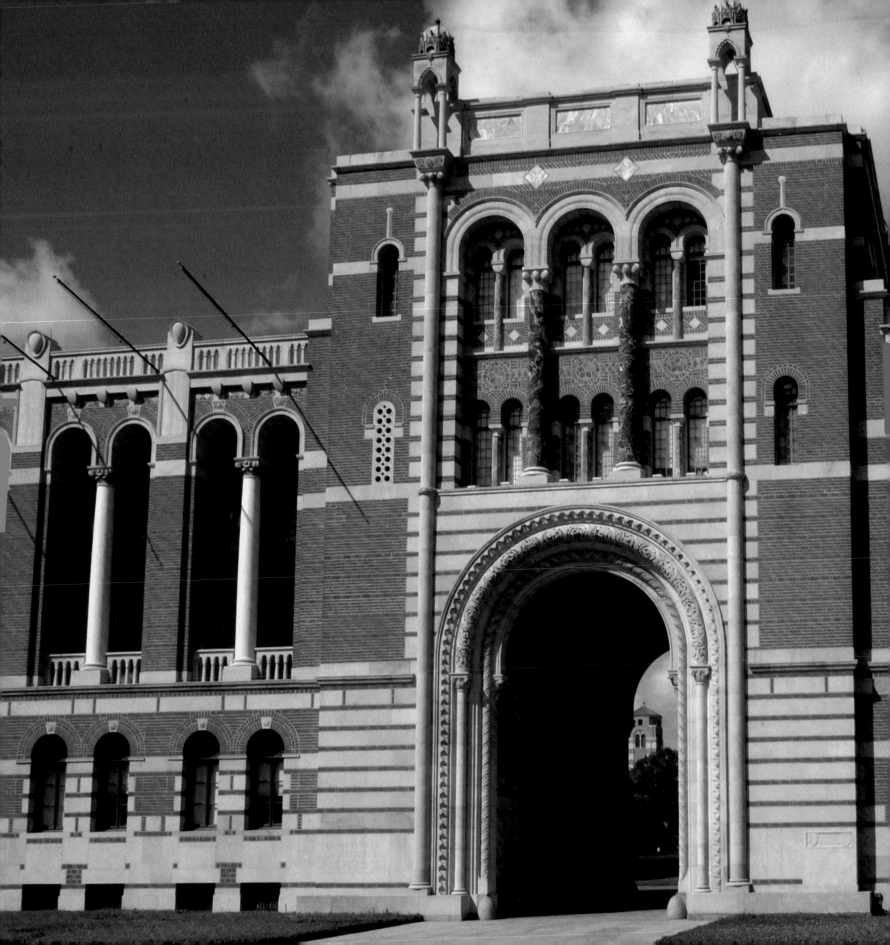

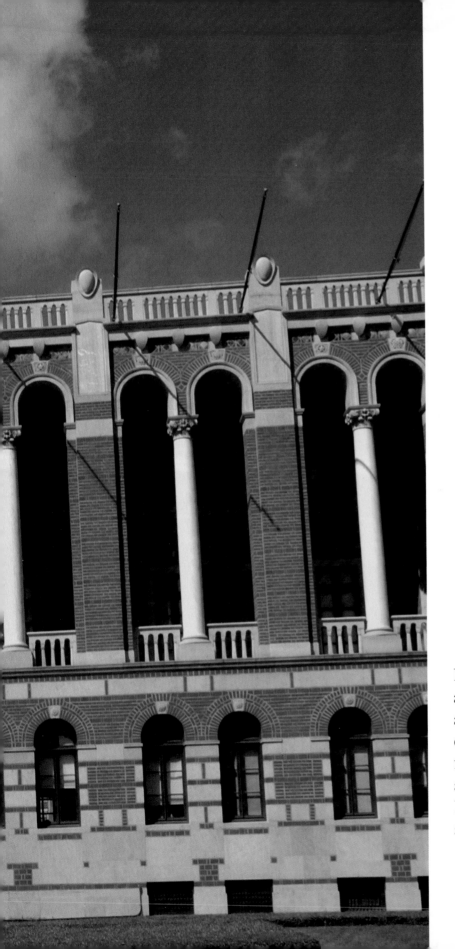

Houston businessman William Marsh Rice set
aside funds to establish a post-secondary school
after his death. In 1900, however, his valet
conspired with a lawyer to kill him and forge a
new will. The school was in jeopardy until
an autopsy proved that Rice had been poisoned.
Rice University opened in 1912 with 77
students, and now enrols more than 4,000.

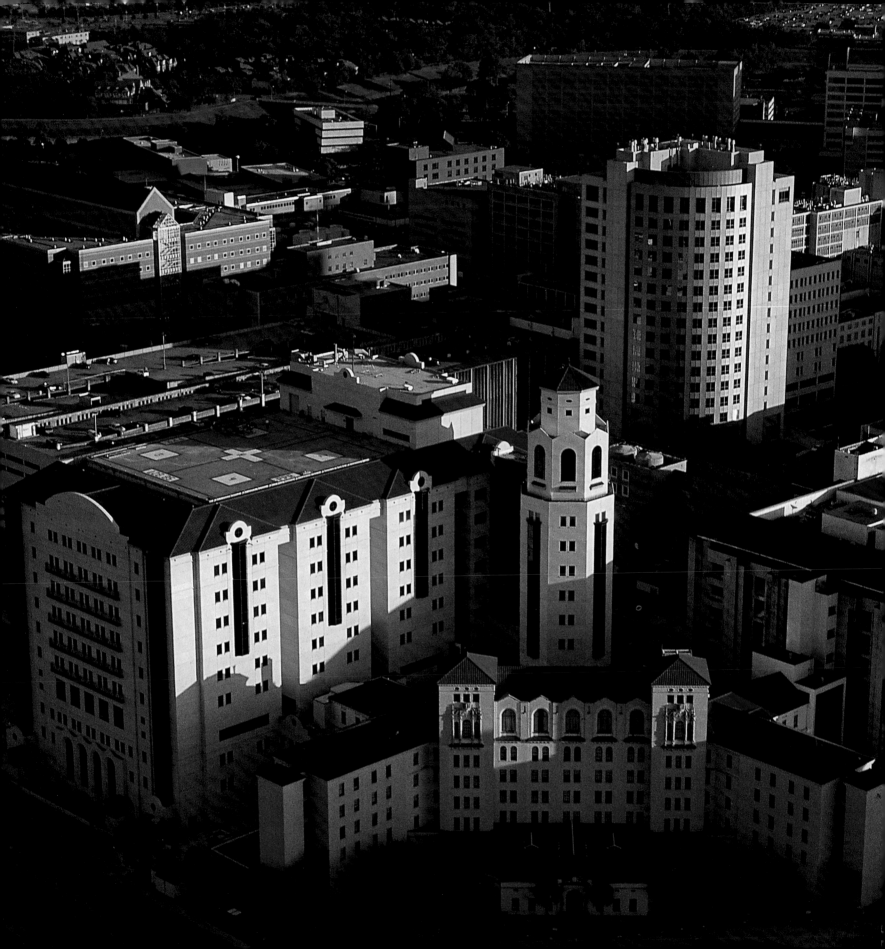

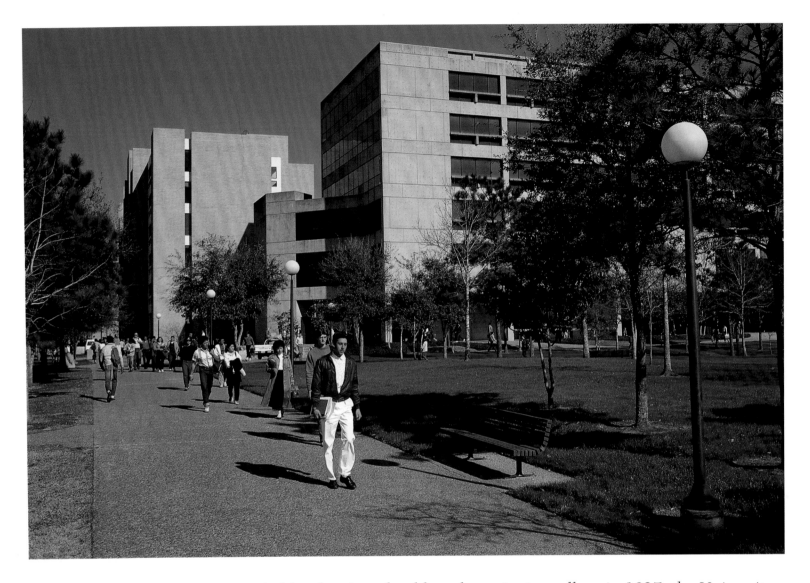

Founded by the city school board as a junior college in 1927, the University of Houston became a four-year college in 1934. Today, the school's 33,000 students can choose from 280 degree programs, from architecture, engineering, and education to law and liberal arts.

The Texas Medical Center, which occupies 700 acres, comprises more than 100 buildings, and includes 42 nonprofit institutions, is dedicated to providing the best health care for people of every economic class. Of the more than 5 million patients treated each year, almost 20,000 arrive from other countries. The center is one of America's premier medical research facilities.

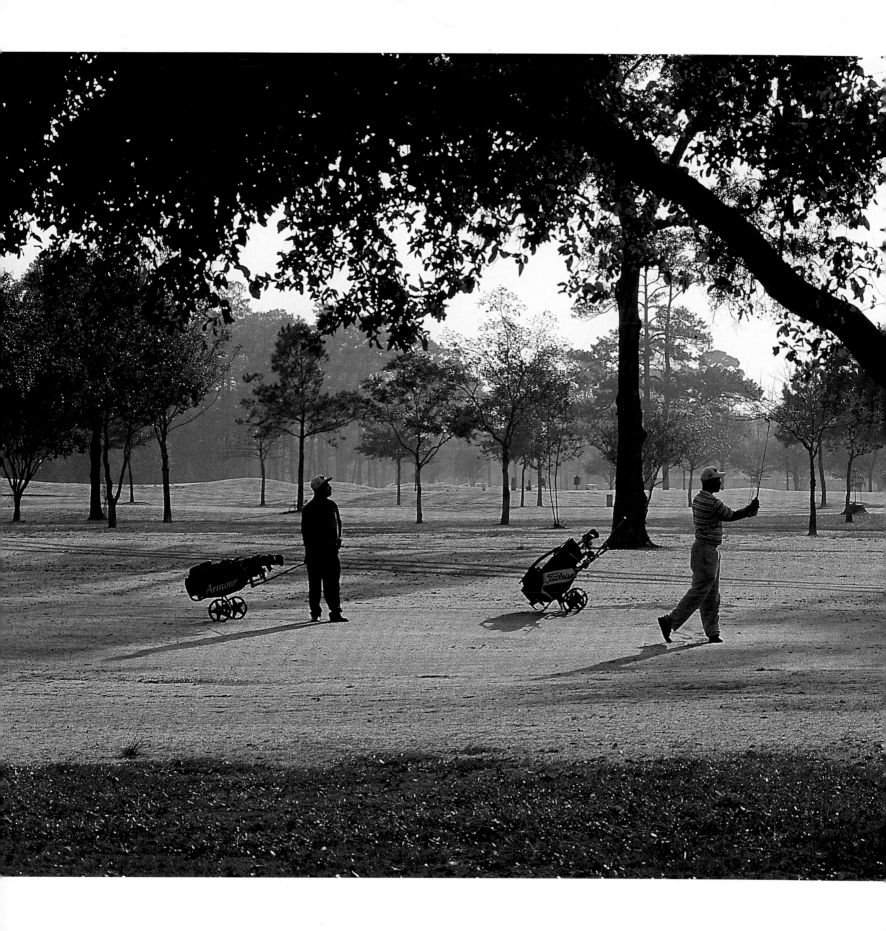

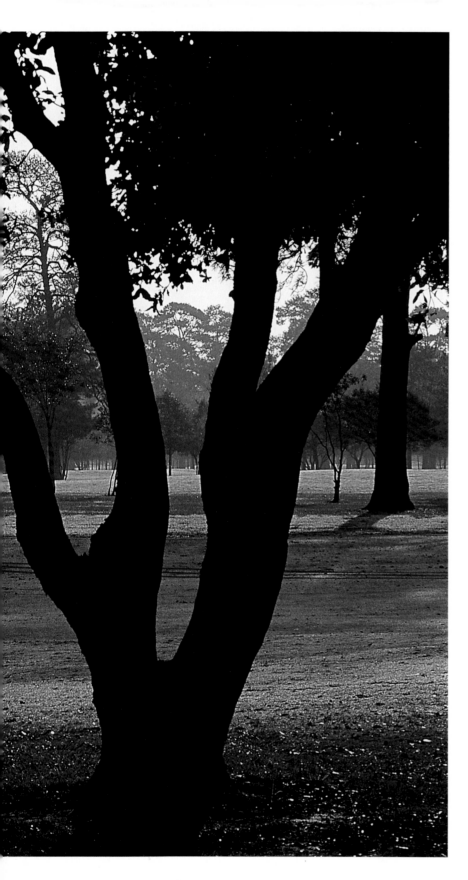

Golfers challenge the links at Memorial Park golf course, just one of the facilities within the 1,500-acre preserve. About 3.5 million runners use the Seymour Lieberman Jogging Trail each year, and other visitors enjoy the 1,500 native flowering trees planted throughout the park.

From a boat launch and children's playground to a disc golf course and hiking and cycling trails, the parks alongside Buffalo Bayou offer year-round recreation. Several annual events—including the Anything That Floats Parade, an exhibition of artistic and unusual vessels—take place on the river.

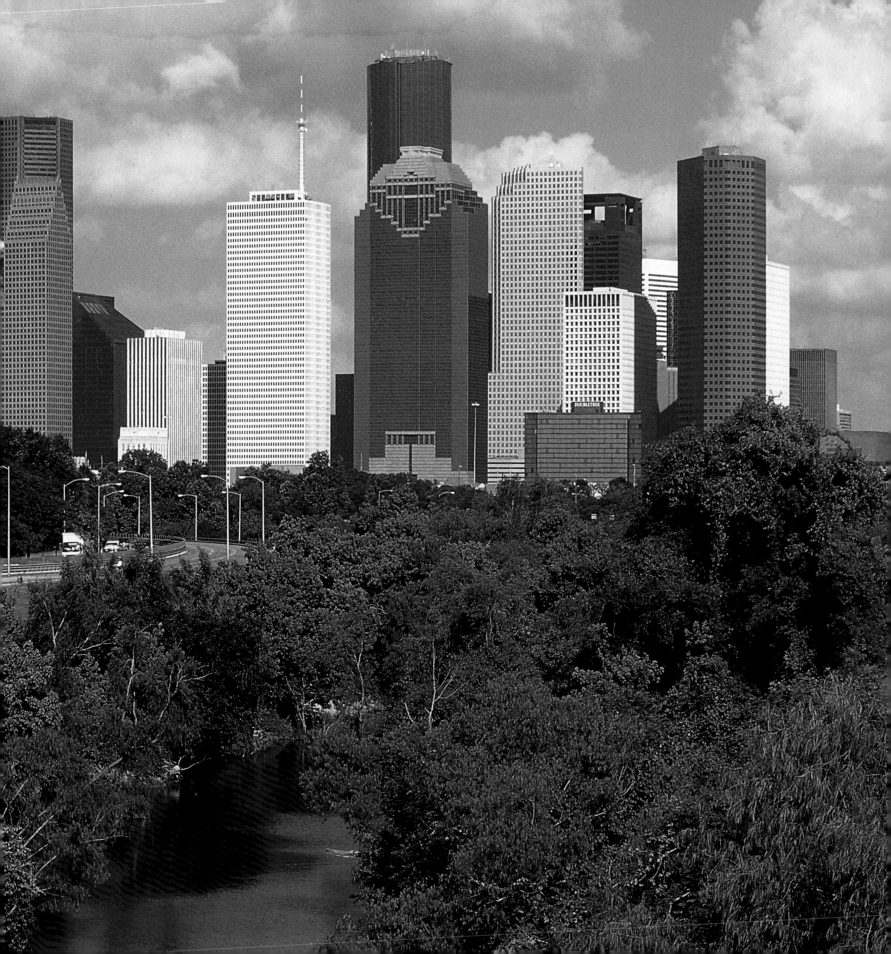

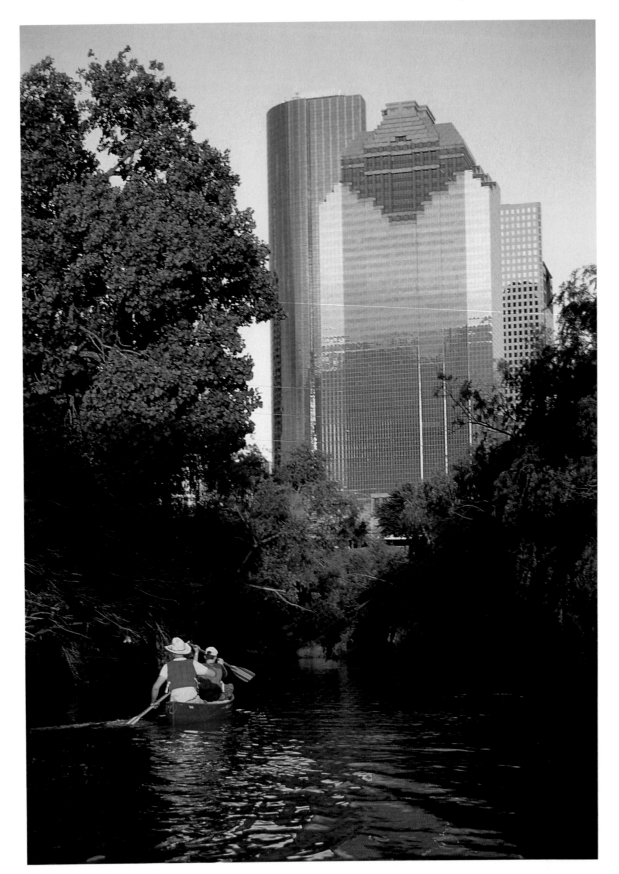

Paddlers navigate the waters of Buffalo Bayou, enjoying views of the downtown skyline. Each year in May, canoes take to the waterway for the Buffalo Bayou Regatta, an eight-mile race to Sesquicentennial Park. For summer visitors, registered guides lead more serene, three-mile circuits.

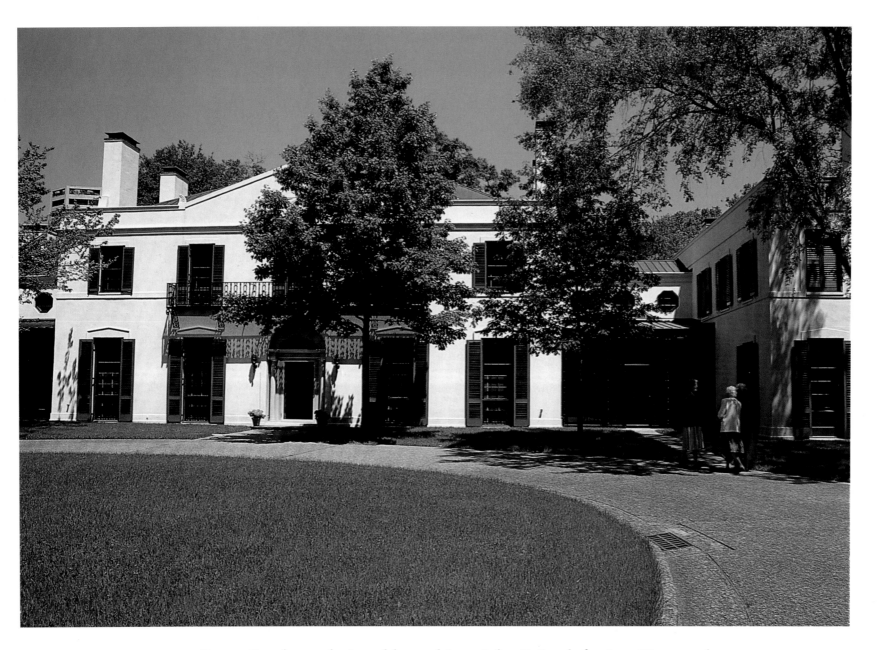

Bayou Bend was designed by architect John F. Staub for Ima Hogg and her brothers, William and Michael. The elegant but uncluttered rooms were designed to showcase Miss Hogg's collection of American decorative arts. Miss Hogg eventually donated her home to the Museum of Fine Arts and supervised its conversion. It opened as a museum in 1966.

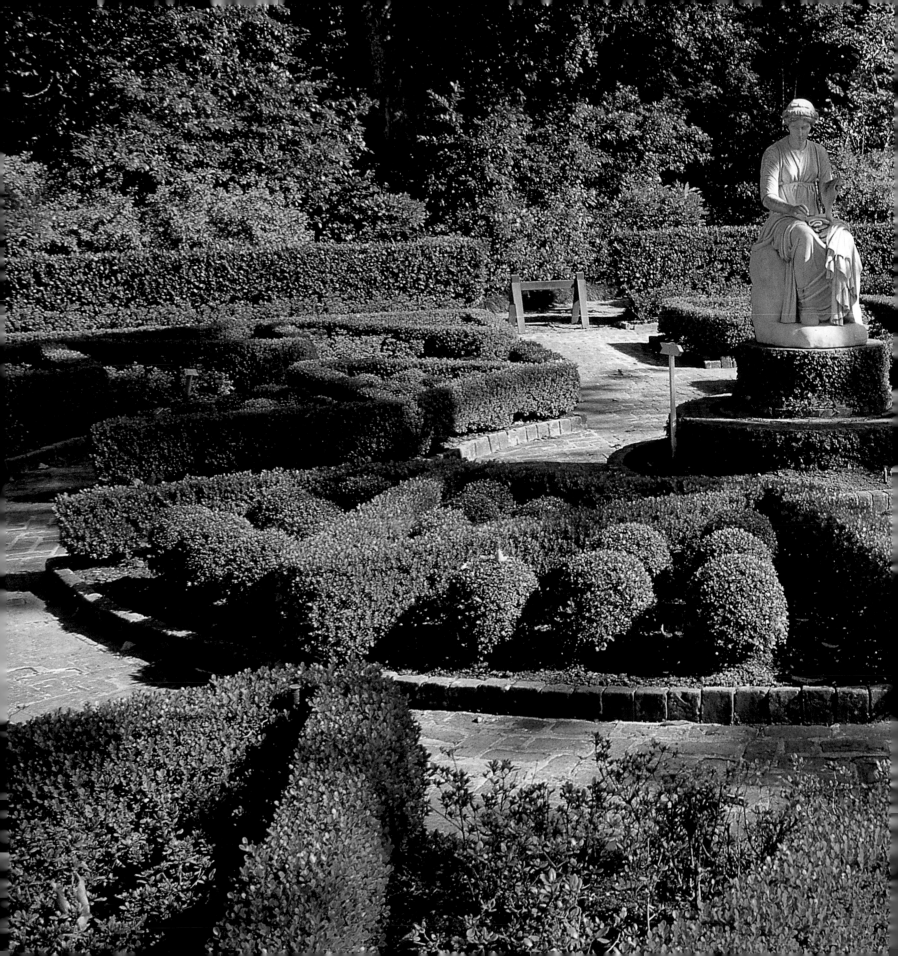

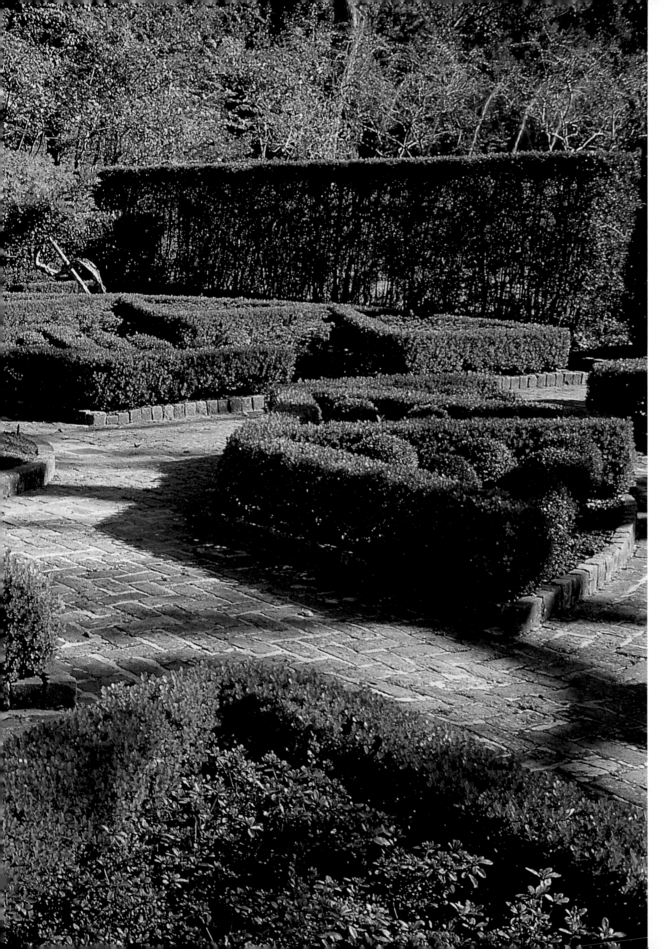

When Ima Hogg first saw the grounds of Bayou Bend, she called them "nothing but a dense thicket." Under her care, however, the land was transformed into formal plantings and lush garden "rooms," as well as natural woodlands. The 14 acres border Buffalo Bayou.

The Heights, Houston's first planned community in 1887, is now a mix of historic buildings, hip retail shops, and antique stores. Some of the area's Victorian homes have been claimed by the city's young businesspeople, attracted by the short commute to downtown.

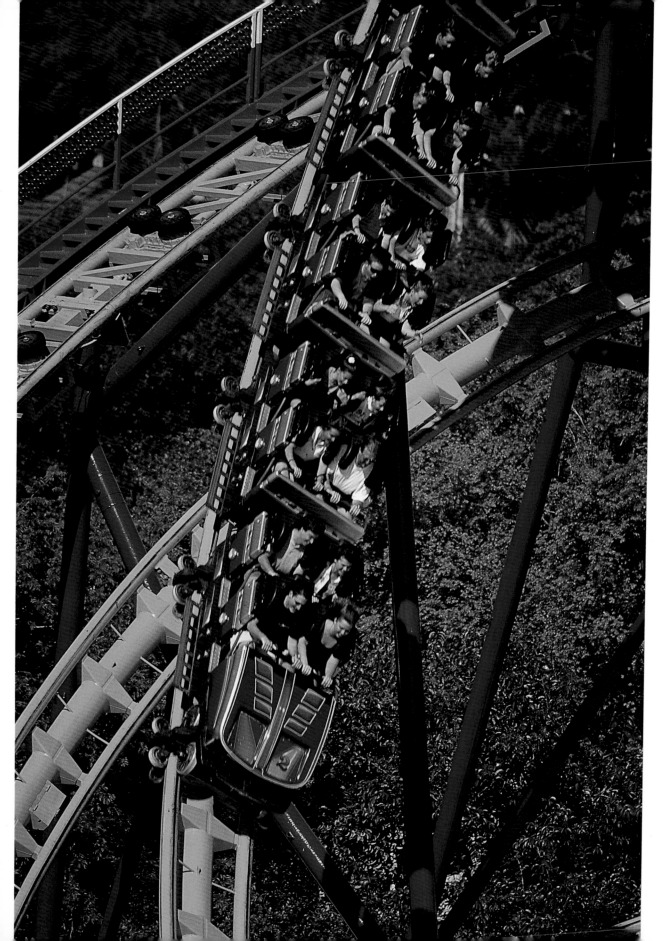

The 32 rides at Six Flags Astroworld include four miles of roller coasters. The giant theme park also features concert facilities, water slides, a western trading post, gift shops, and restaurants.

When the Colt.45s baseball team moved into the world's first multi-purpose domed stadium in 1965, the space race was firing local imaginations and the team became the Astros. Baseball has since moved to downtown's Minute Maid Park, but the Astrodome remains a Houston landmark and home of the Houston International Livestock Show and Rodeo.

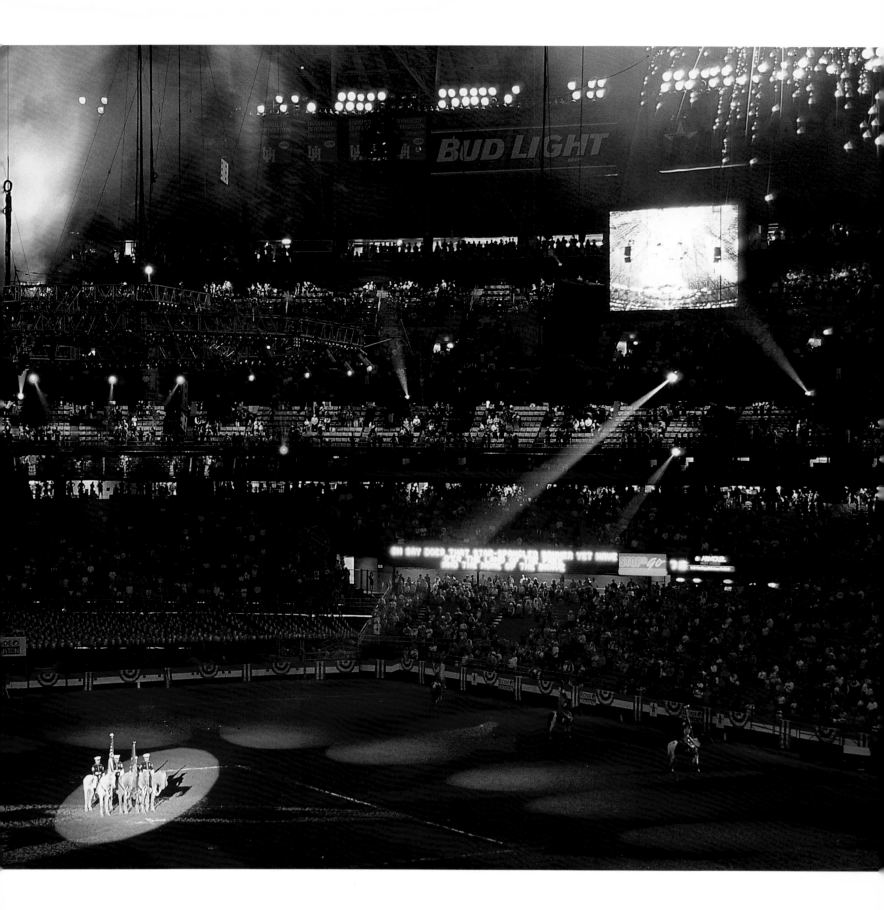

Houston's South Loop is one of the city's fastest-growing areas. Events at the Astrodome, Reliant Stadium, and Reliant Center, a conference and exposition venue, make this a popular entertainment district.

60

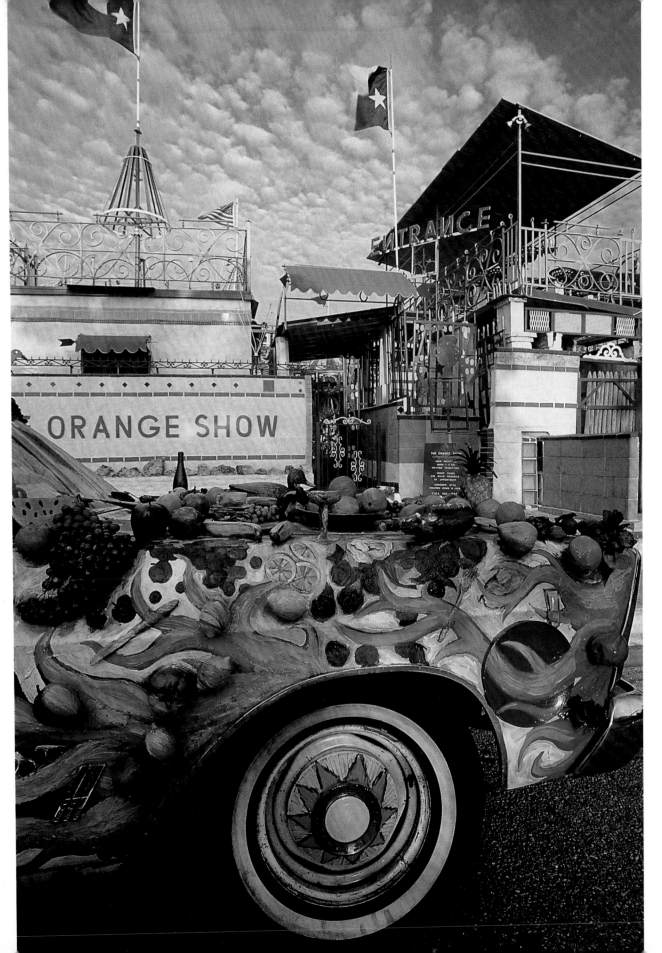

An eccentric maze of folk art, the Orange Show was the vision of Jeff McKissack. The local postal worker was so obsessed with oranges that he built a museum to celebrate the fruit. He died in 1980, soon after opening his collection to the public.

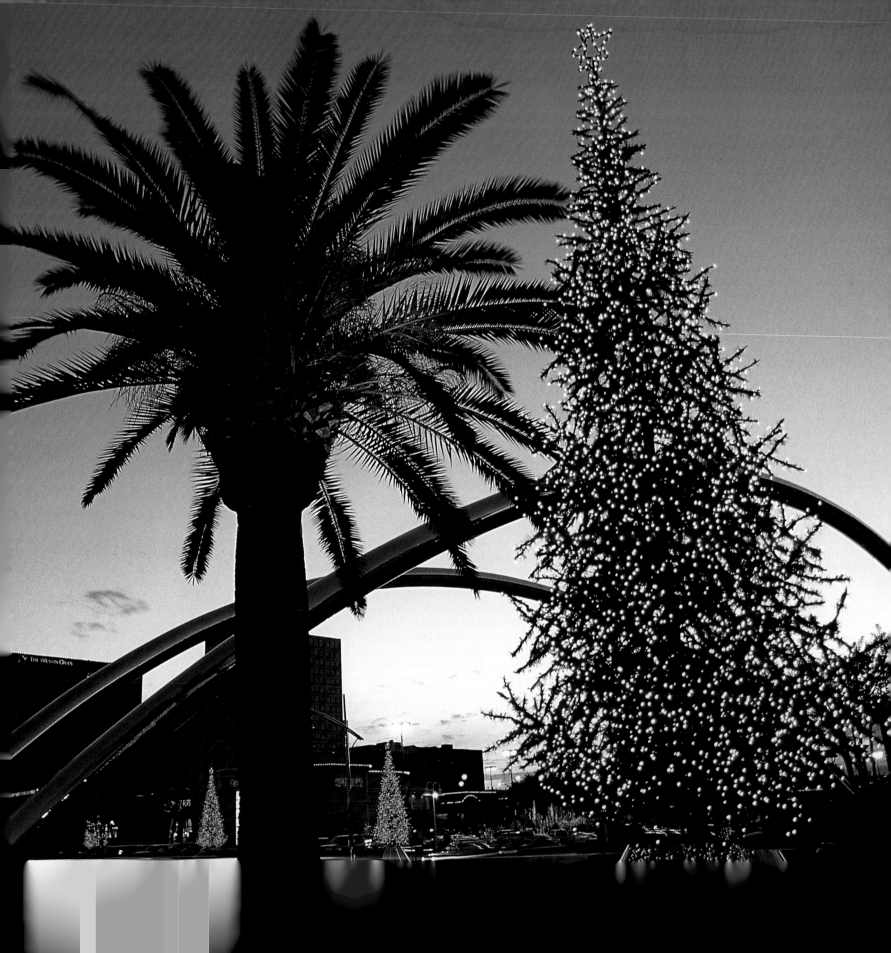

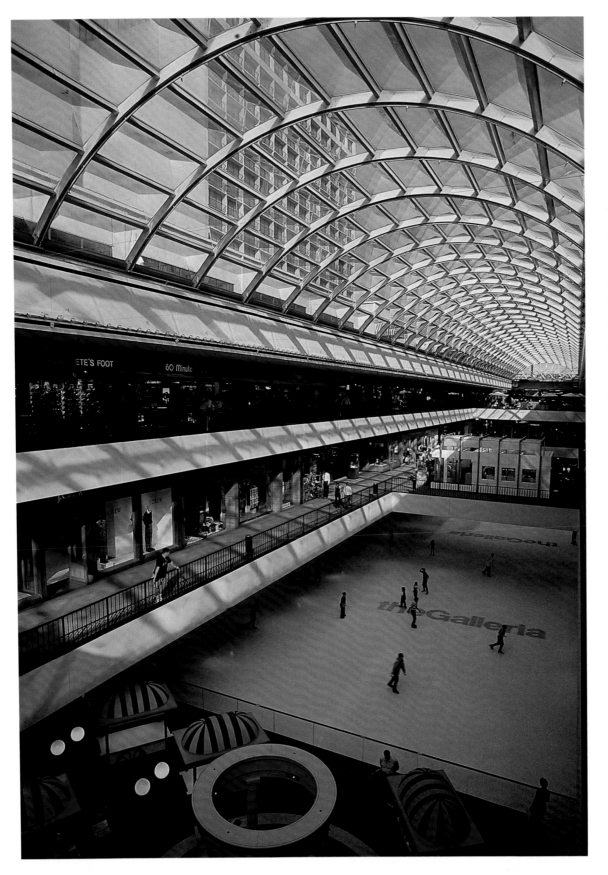

Houston's premier shopping destination, the Galleria houses an ice rink, two hotels, and more than 300 stores and restaurants. From designer boutiques to trendy youth-oriented stores, the complex's 1.7 million square feet of retail space have something for everyone.

FACING PAGE
As Thanksgiving ushers in the festive season, thousands of Houston residents gather to witness the Uptown Holiday Lighting. Choirs perform, bands play, fireworks are set off, and more than half a million lights twinkle to life on 80 Christmas trees and the surrounding streets and skyscrapers.

Williams Tower soars to 64 stories, America's highest suburban office building. Architect Philip Johnson and developer Gerald D. Hines created the stone and glass skyscraper to echo early tower design of the 1920s. An observation deck on the fifty-first floor gives a panoramic view of the surrounding park and the Houston skyline.

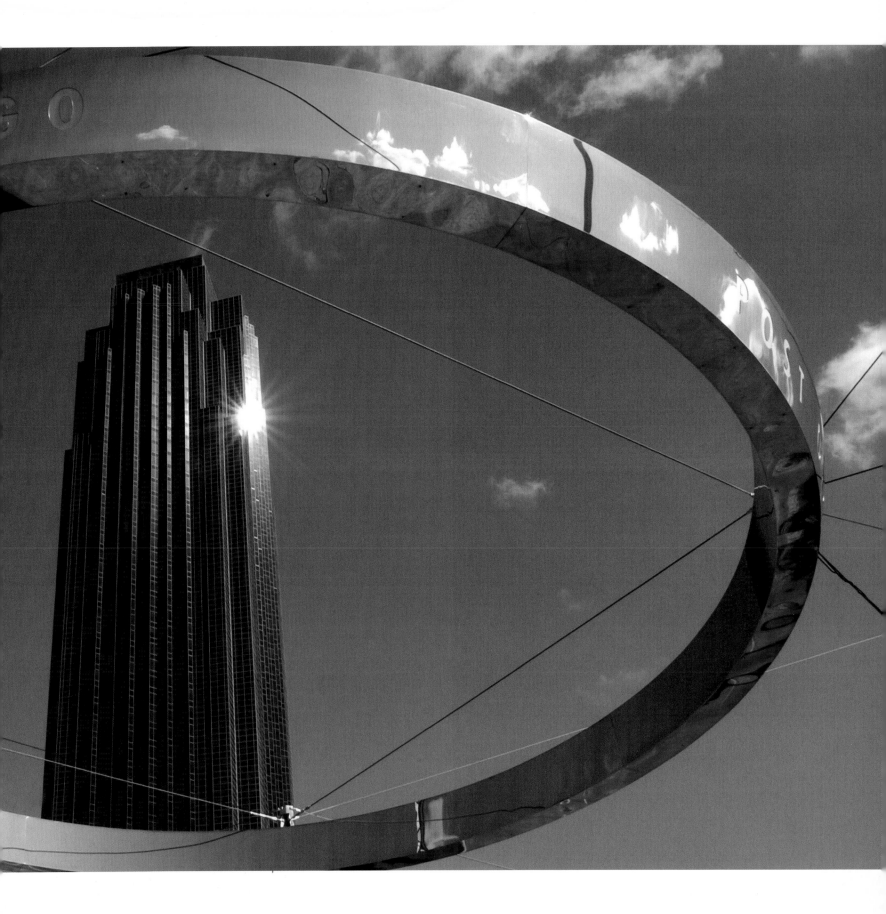

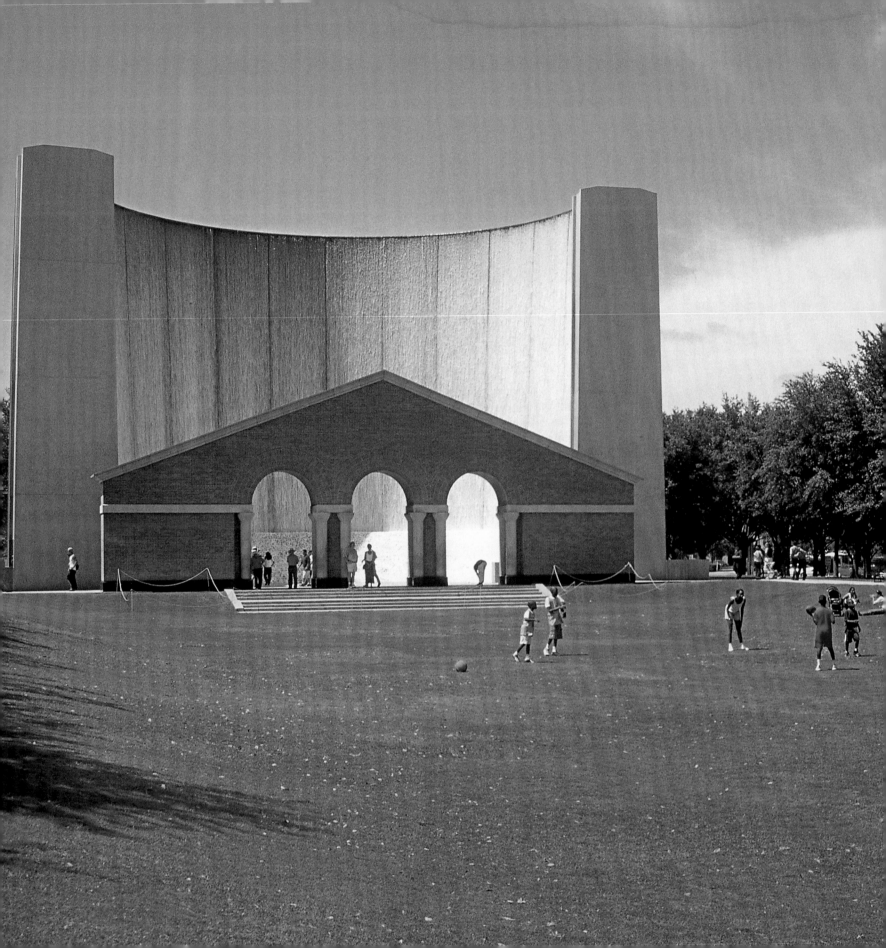

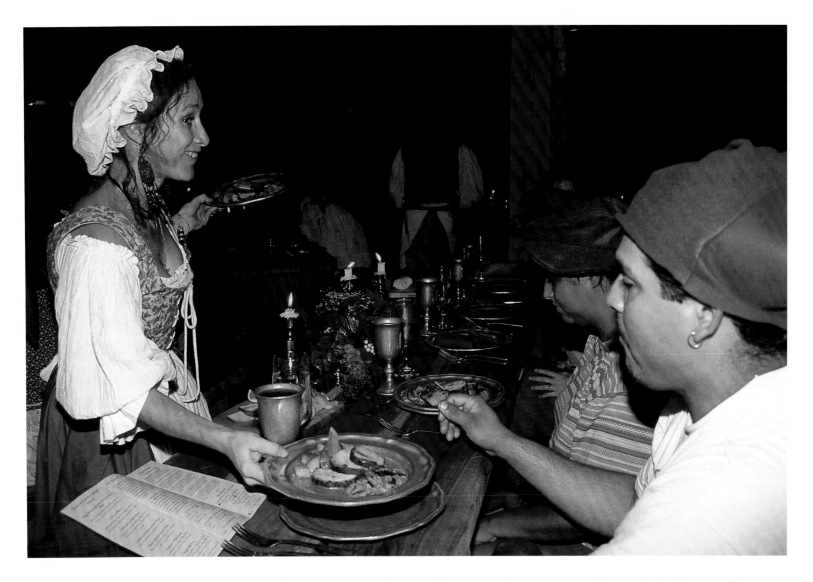

A "wench" serves revelers at the Texas Renaissance Festival, held in a 54-acre replica of an English village just outside Houston. Each fall, sightseers at New Market Village find a harvest celebration underway, including juggling, jousting, acrobatics, music, and dancing.

Water cascades down both sides of the horseshoe-shaped Water Wall at Williams Tower. Created by Philip Johnson and John Burgee in the 1980s to complement the skyscraper above, the structure recycles 78,500 gallons of water every 3.5 hours.

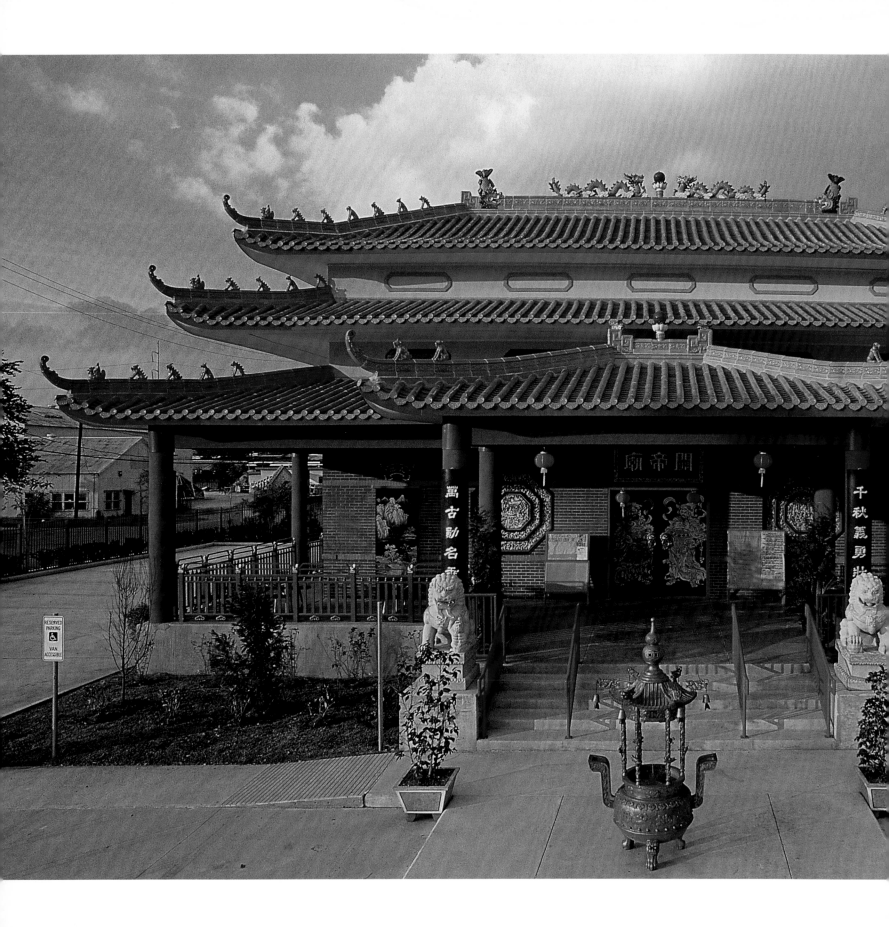

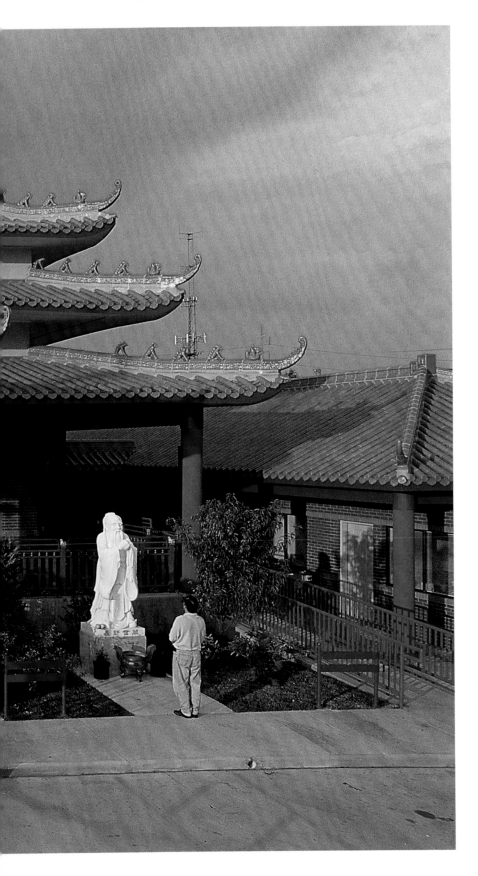

One of several Buddhist places of worship in the city, the Taxas Guandi Buddhist Temple is one symbol of Houston's diverse population. There are more than 90 languages spoken within the city. Restaurants represent more than 35 ethnic groups, and consulates posted here represent 77 nations.

Johnson Space Center was founded in 1961 and renamed in 1973 in honor of President Lyndon B. Johnson. While other centers across the nation control shuttle launches and research, Johnson Space Center concentrates on the human aspects of space exploration, including projects for the International Space Station.

In 1961, President John F. Kennedy predicted that by the end of the decade, Americans would walk on the moon and return safely to earth. This Apollo rocket at Space Center Houston celebrates the fulfilment of that prediction. Neil Armstrong and Edwin "Buzz" Aldrin, the first men to walk on the moon, were followed by the astronauts of six other successful Apollo missions.

70

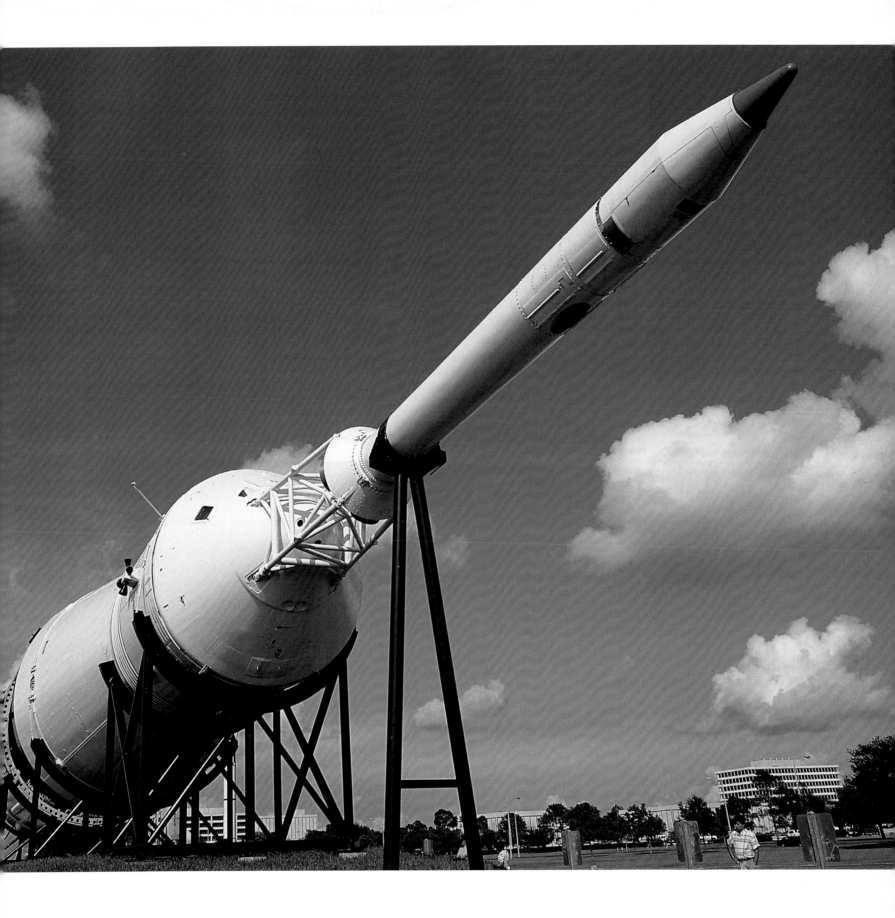

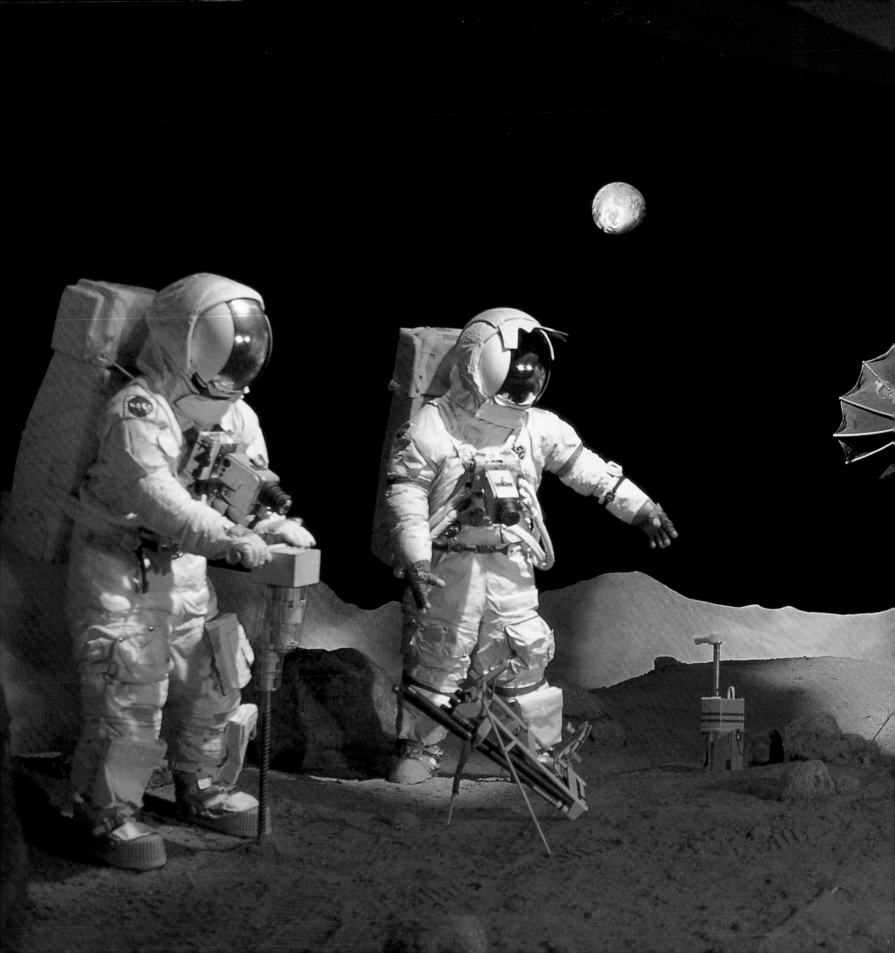

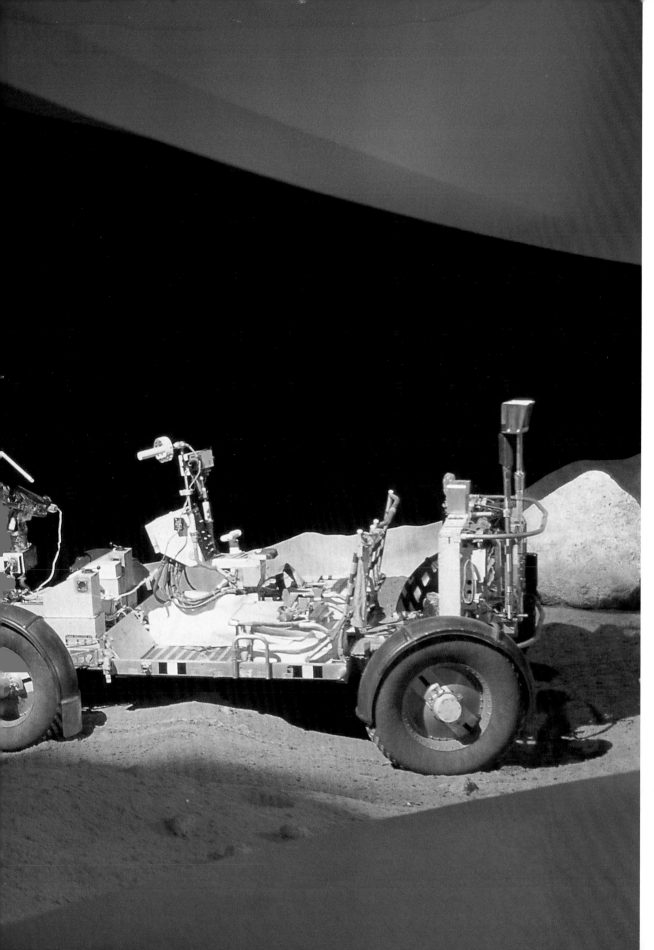

While NASA's mission control and astronaut training takes place at Johnson Space Center, visitors are welcomed next door at Space Center Houston. Hands-on displays allow participants to simulate landing a shuttle or retrieving a satellite from space. Other exhibits explain how astronauts are trained, how they eat and sleep in zero gravity, and how today's engineers are preparing for future exploration.

Each August, attention at Johnson Space Center turns from rockets to hot air balloons, as balloonists from across the continent take part in races, evening balloon glows, and exhibits. The festivities also include skydiving competitions, craft shows, and aviation demonstrations.

Anthony Lucas discovered oil 90 miles northeast of Houston in 1901 and within a year, Houston was home to the world's largest independent refinery. By the mid-1900s, more than 260 oil fields surrounded the city. Oil remained the major industry until the 1980s, when dropping prices forced the region to diversify.

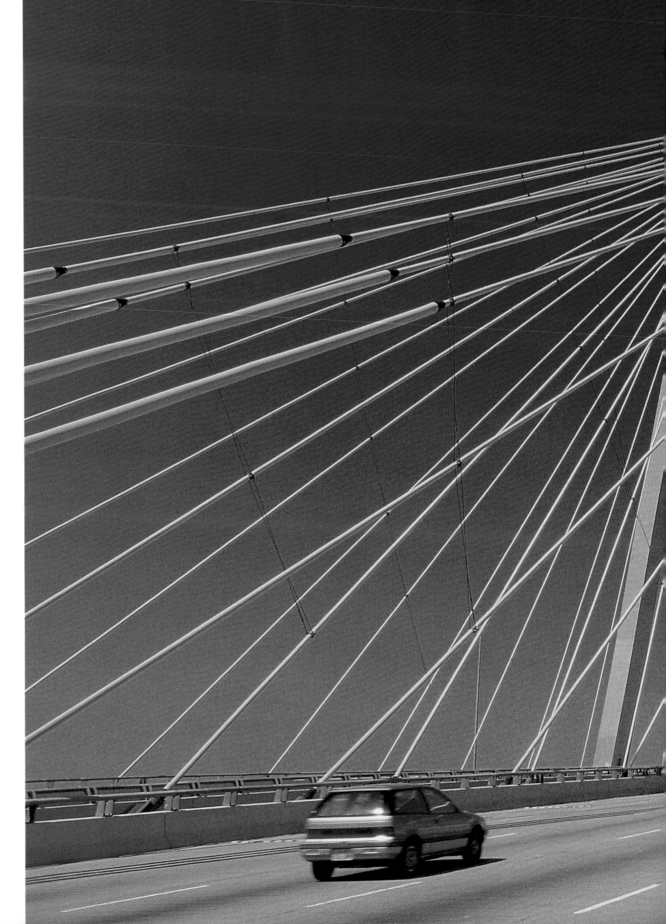

Completed in 1995, the
Fred Hartman Bridge is
a 1,250-foot-long span,
supported by 192 stay-
cables arranged in a fan
pattern above the eight
lanes of traffic. The
bridge, named for the
publisher of the *Baytown
Sun*, crosses the Houston
Ship Channel to link
La Porte and Baytown.

76

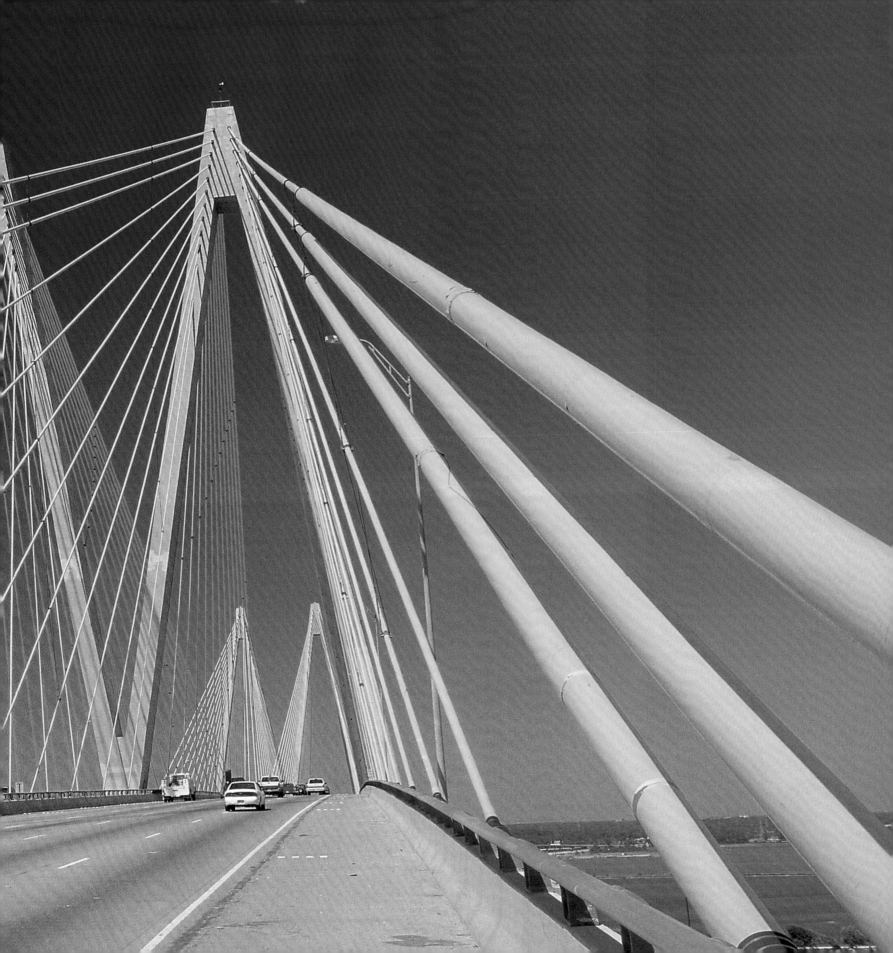

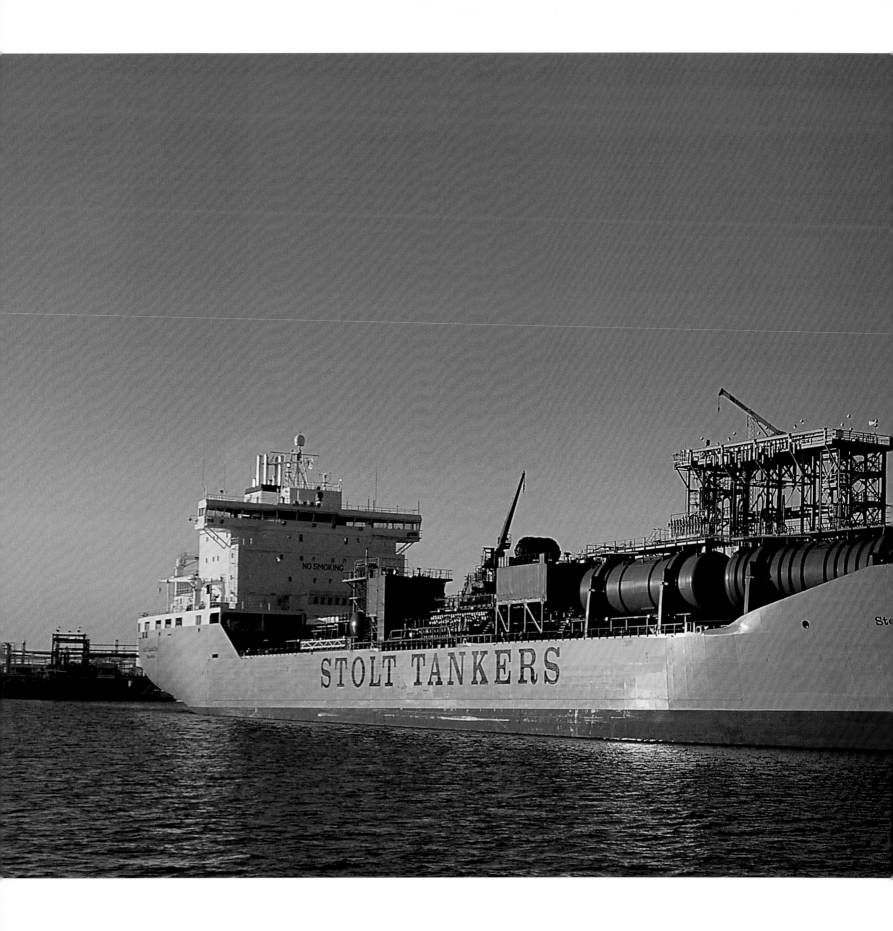

In the 1800s, Texas farmers brought their products to Houston to be shipped down Buffalo Bayou to the natural port in Galveston. When Houston merchants and Galveston leaders butted heads over profits in the 1850s, plans to widen Buffalo Bayou and create the Houston Ship Channel were born. Opened in 1874, the channel helped to make the Port of Houston one of the busiest in the nation.

The world's tallest monument column, the San Jacinto Monument towers 570 feet high. Construction began in 1936, a century after Sam Houston led his forces to victory over the Mexican forces who had previously controlled Texas. The Mexican troops were forced to retreat south of the Rio Grande.

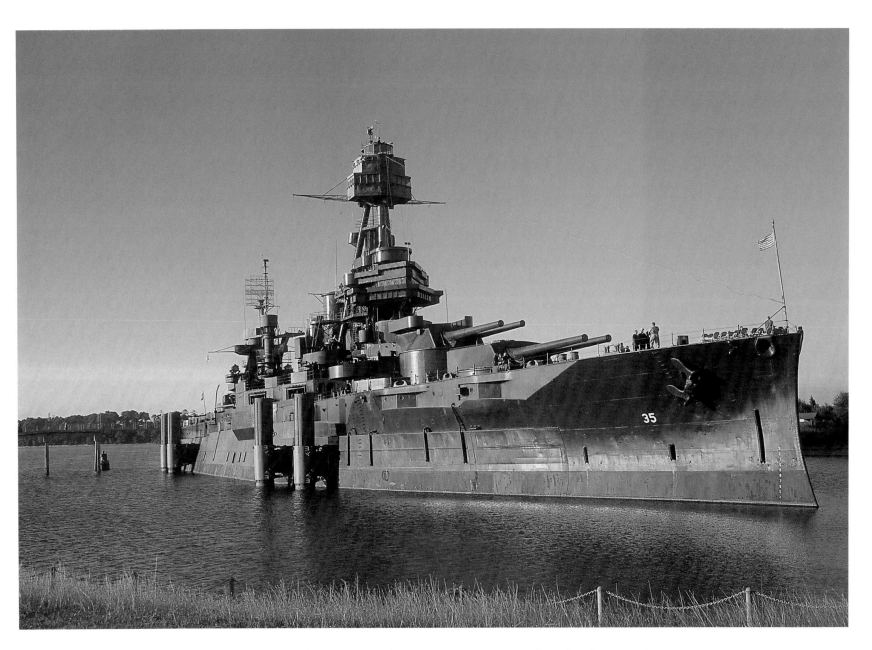

Commissioned in 1914, the USS *Texas* served in both world wars, equipped with the navy's latest technology. In 1948, the vessel became America's first battleship memorial. As a state historic site, the ship allows visitors a personal view of the lives of navy sailors in the first half of the twentieth century.

A celebration of Galveston's seafaring past, the Texas Seaport Museum includes the tall ship *Elissa*, built in Scotland in 1877. After visitors have explored the historic ship, they can step inside the nearby museum, where it is possible to research family trees. About 133,000 immigrants entered America through Galveston.

Overleaf
In the late 1800s, Galveston was the "Queen City of the Gulf," home to cotton merchants, mercantile houses, banks, mills, railroad headquarters, and shipping companies. Today tourism is a mainstay of the local economy.

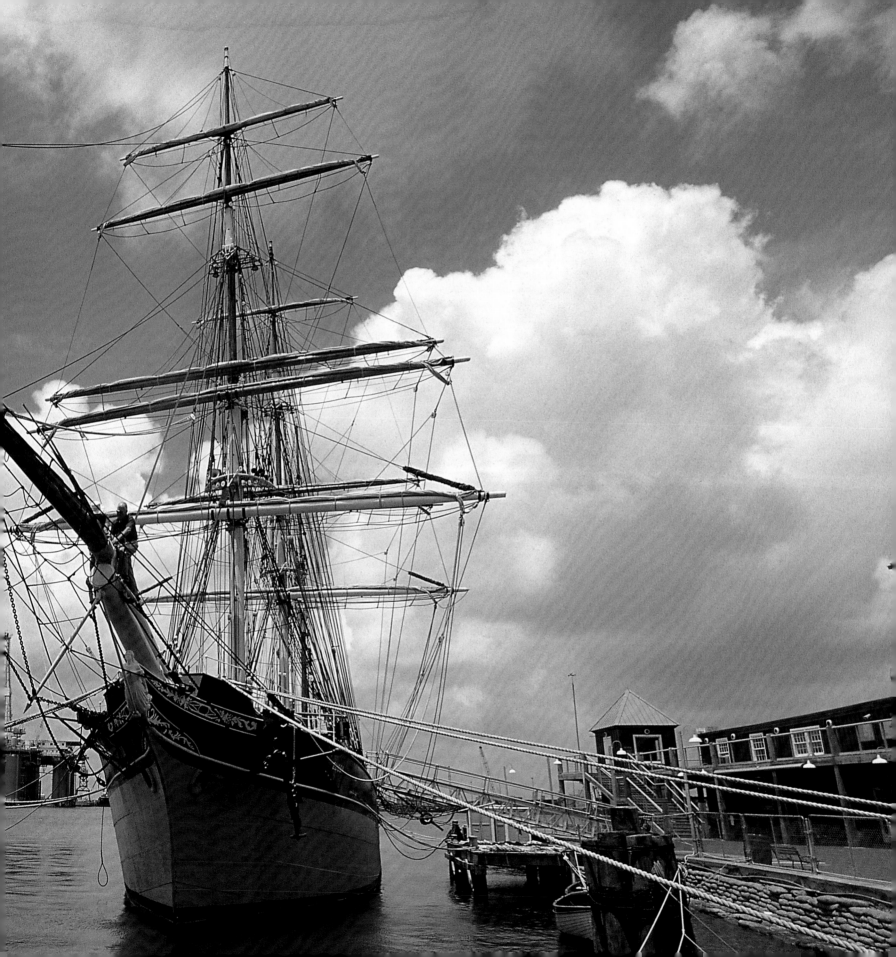

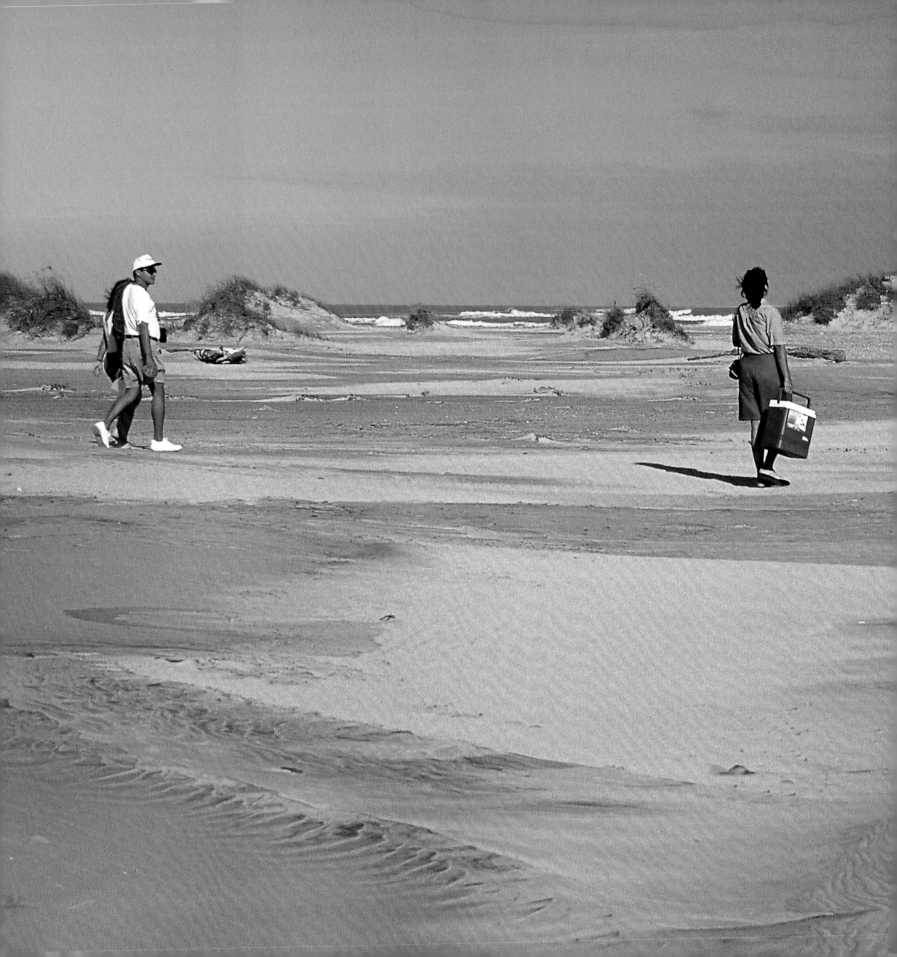

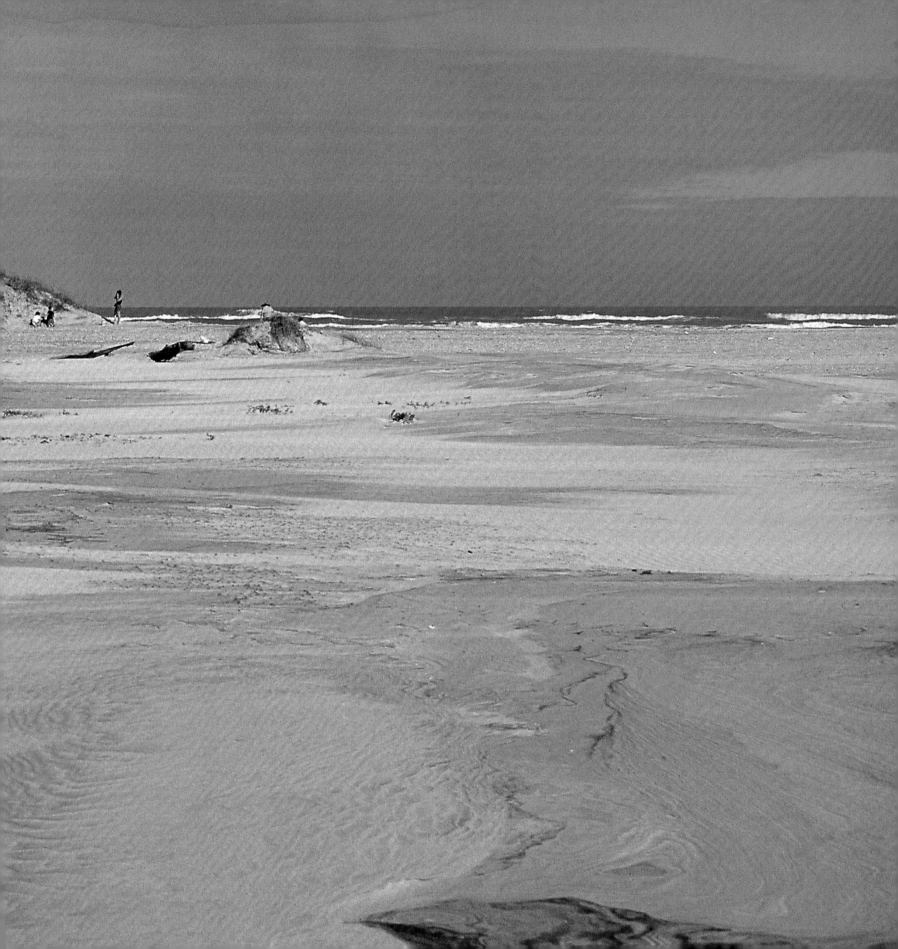

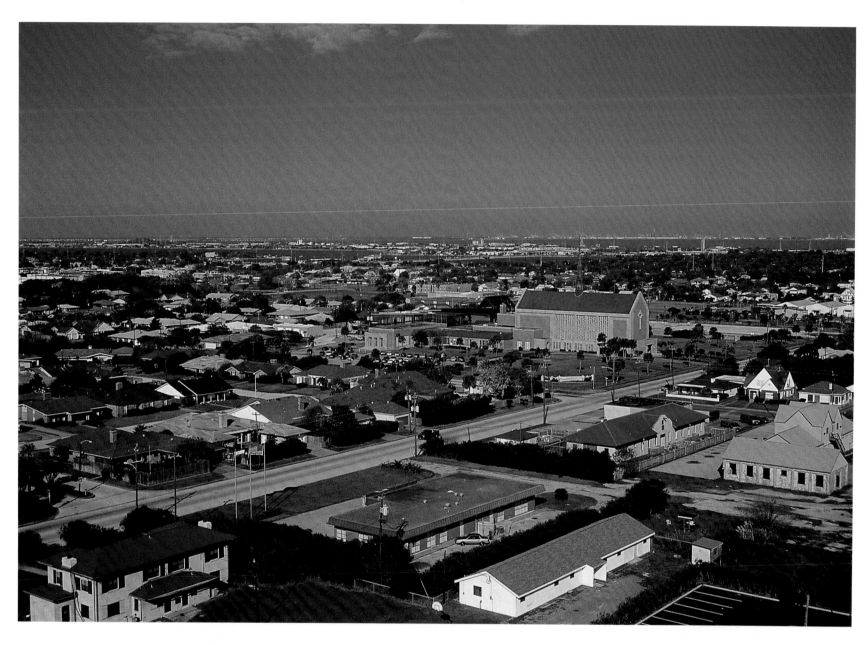

It's only 30 miles long and two miles wide, but Galveston Island has many attractions, from white sand beaches and historic buildings to Mardi Gras celebrations, the annual Spring Fest, and the Kite Festival. Pirates in Paradise events each fall include concerts, parades, and, of course, treasure hunts.

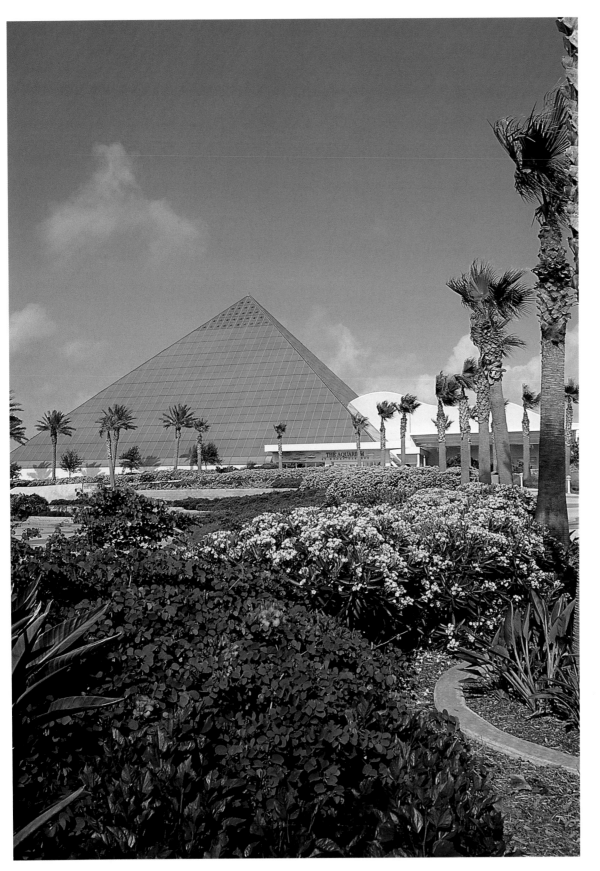

Moody Gardens opened in the 1980s as an equestrian center for people with head injuries. In the last few decades, it has expanded to become one of the state's premier attractions, providing both education and entertainment. Moody Gardens also works with American universities and hospitals to explore the medicinal potential of rare plants and insects.

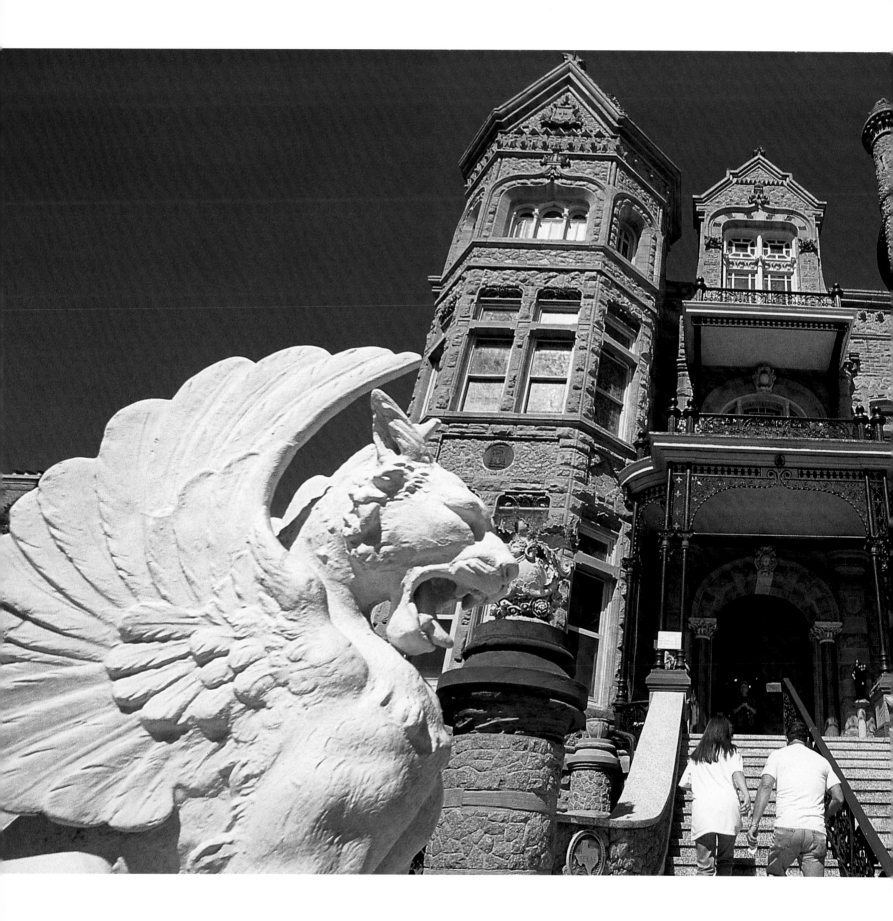

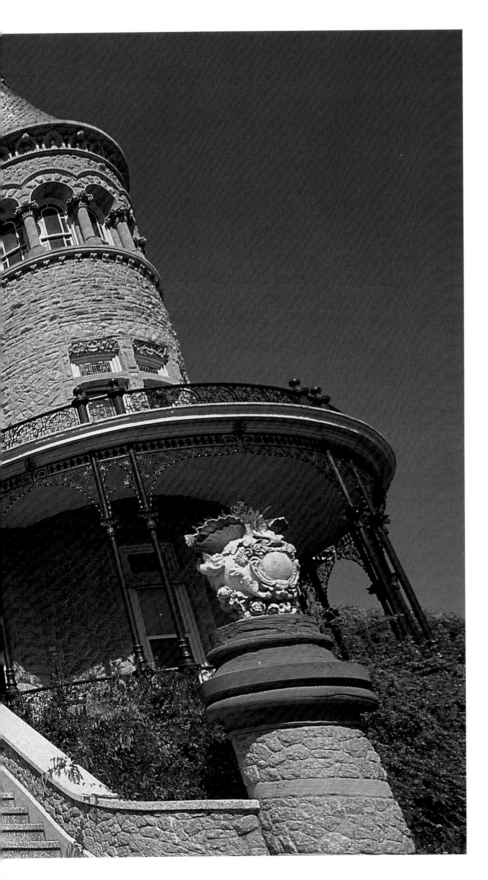

Originally built for politician Walter Gresham, this castle-like structure on Galveston Island is known as the Bishop's Palace. The Catholic Diocese bought the building in 1923, to serve as the home of local bishops. In 1963, the church opened the mansion as a public museum. The American Institute of Architects has named this one of the nation's 100 most outstanding buildings.

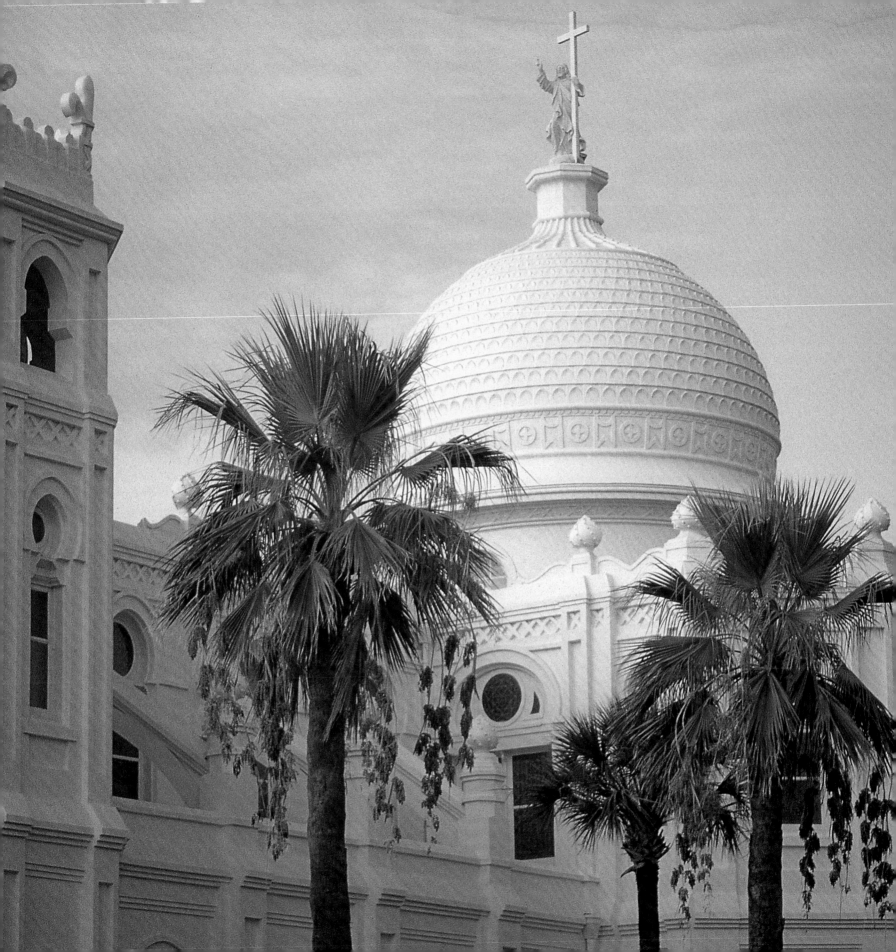

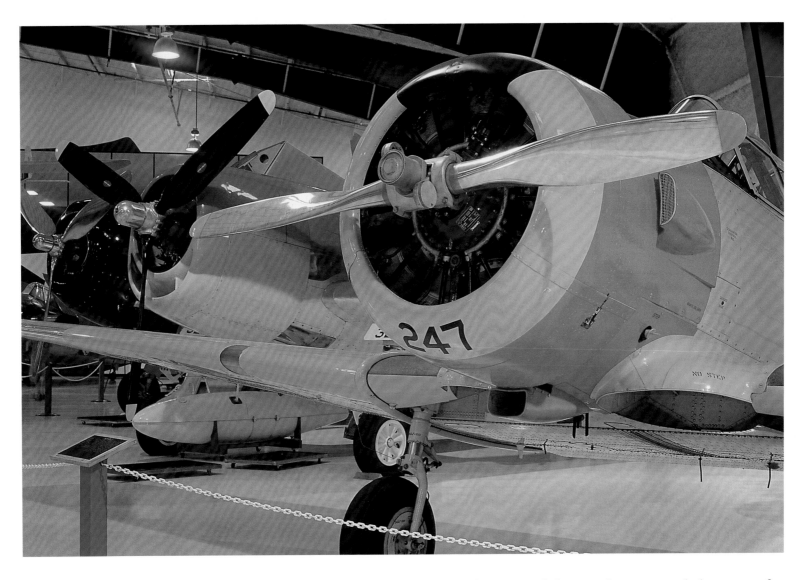

The Lone Star Flight Museum in Galveston celebrates the accomplishments of flight pioneers and commemorates the lives of those who have flown in combat around the world. Second World War bombers, fighter jets, and cargo planes are on display, and volunteers dressed in authentic period uniforms interpret the events of the war years for visitors.

The first Catholic Church in Galveston was swept away by the storm of 1900. The present Sacred Heart Catholic Church was built in 1904 according to the designs of Brother Peter Jiménez, who modeled his creation on churches in Spain and New Orleans.

Twenty-two miles north of Houston is Mercer Arboretum and Botanic Gardens. Begun in the 1940s as the home of Charles Mercer and his wife, Thelma, a talented horticulturist, it was purchased by Harris County in 1974. Today the gardens cover 250 acres showcasing herbs, tropical plants, endangered species, and natural woods.

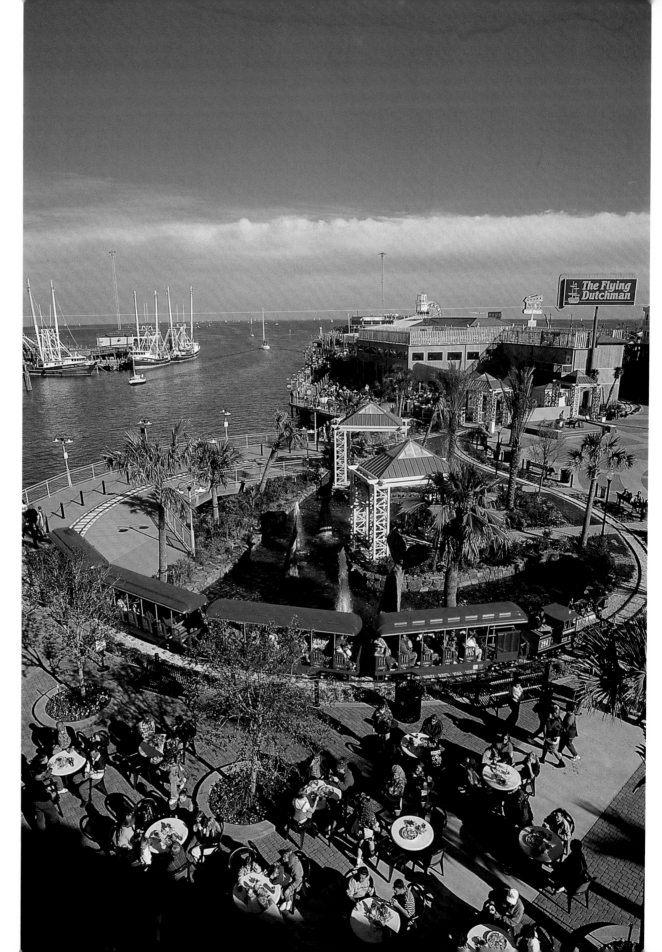

Restaurants and specialty shops line Kemah Boardwalk, 30 minutes from downtown Houston, making this a favorite evening or weekend destination. Midway games, a carousel, and a miniature train add to the carnival atmosphere.

94

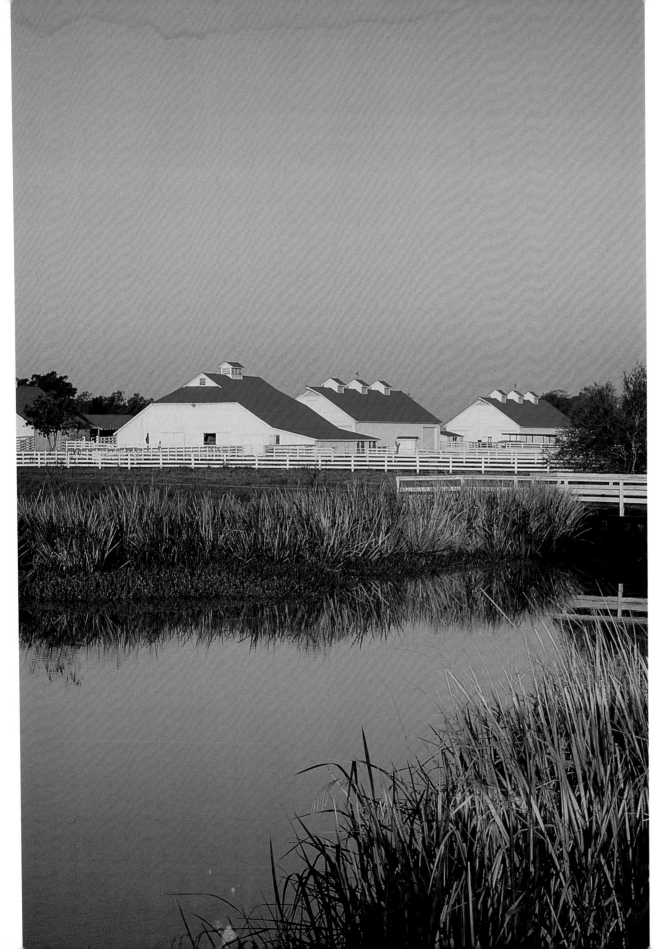

Surrounded by 23,000 acres of ranch and farm-land, George Ranch Historical Park is a working reminder of the state's frontier past. From cattle drives and cowboy camps to the discovery of oil, the ranch explores 100 years of local history.

Photo Credits